Foreword

The wondrous menagerie of porcelain animals described in this catalogue reflects a unique combination of historical circumstances. An interest in experimenting with new technologies – the formula for porcelain had only recently been discovered in Germany – and Augustus the Strong's extravagant taste resulted in the ambitious project to create life-size porcelain animals for his palace in Dresden. Artistic virtuosity and human ingenuity made nature's splendor permanent in this remarkable representation of exotic and common species.

This publication accompanies the display at the J. Paul Getty Museum of fourteen animals from the Dresden Porcelain Collection, marking one of the first times that such a large, representative group has been exhibited outside Europe. It was made possible by an ongoing and mutually beneficial partnership between the Getty and the State Art Collections of Dresden, with the gracious help of Sybille Ebert-Schifferer, Director General of the State Art Collections. The assistance and expertise of Ulrich Pietsch and Hans Martin Walcha, Director and Conservator, respectively, of the Dresden Porcelain Collection, were also invaluable. Maureen Cassidy-Geiger, an independent scholar, provided essential help and advice. I am equally indebted to those members of the Getty staff whose hard work and genuine enthusiasm guaranteed the success of the exhibition: Catherine Comeau, Brian Considine, Mark Greenberg, Quincy Houghton, Bruce Metro, Merritt Price, Jeffrey Weaver, and Gillian Wilson.

This catalogue was first published in Dutch and German to accompany an exhibition of the Dresden porcelains in Amsterdam, where they joined the Rijksmuseum's own holdings of eleven animals. I am grateful to the Rijksmuseum for generously granting permission for this English edition, as well as to Samuel Wittwer for his excellent text and David McLintock for his faithful translation. References to, and images of, the Rijksmuseum's animals have been retained in the catalogue, where they provide a fuller context for the examples on display in Los Angeles.

This volume is a tribute to the quizzical passions of Augustus the Strong, whose remarkable collection of porcelain animals still has the power to delight the museum-going public.

Deborah Gribbon
Director
The J. Paul Getty Museum

Cover:

Front: detail of fig. 8

Spine: detail of fig. 29

Back: detail of fig. 13

Inside cover:

Front: detail of fig. 28

Back: detail of fig. 9

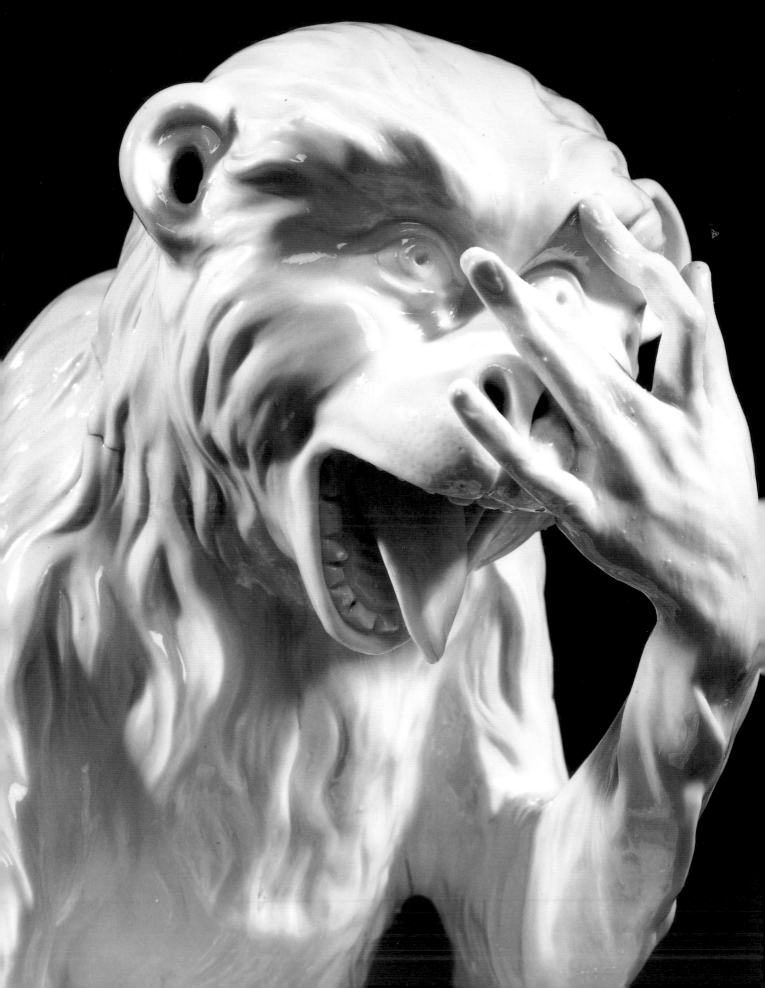

THE JAPANESE PALACE IN DRESDEN

On September 10, 1719, a special celebration took place in Dresden. It marked the wedding of the only legitimate son of Augustus the Strong, elector of Saxony and king of Poland, and ushered in several weeks of festivities. The crown prince, who later reigned as Augustus III, married Maria Josepha, the daughter of the Holy Roman Emperor Joseph I. The Saxon ruling house thus moved to the front rank of German nobility.

The festivities took place in a small pleasure palace on the bank of the Elbe River that Augustus the Strong had purchased from his minister Count Jakob von Flemming. The minister built the palace in 1715, and it had been the residence of the Dutch special ambassador. Decorated in the Dutch style currently in vogue, the palace was at first called the Dutch Palace. In preparation for the wedding, Augustus the Strong enlarged and lavishly furnished it. In historical writings from as early as 1720 it is called the Japanese Palace, perhaps because after the elector bought it in 1717, his *Kunstkammer* (art treasury), which included many Japanese and Chinese works of art, was accommodated in a number of top-floor rooms.

Augustus the Strong's intentions didn't end with the expansion and refurbishing of the Japanese Palace for the wedding: he wanted to display his large collection of Oriental porcelain in a different setting. A plan preserved in the Dresden Office for the Care of Monuments shows that in about 1722 he wished to devote a whole floor of Schloss Pillnitz (which was to be extended and become a kind of Saxon Versailles) to his fragile Chinese and Japanese treasures. However, for various reasons, the king's ambitious plan to extend this palace, which lay upstream from Dresden, soon had to be abandoned. So he turned his attention once more to the Japanese Palace, which since 1719 had continued to provide a fine setting for court festivities and was still essentially unchanged.

By about 1725, plans were made to enlarge the small palace and turn it into a splendid setting for the royal porcelain collection. Eventually, the king decided to proceed with a design for a building with four wings that would incorporate, on the side nearest the Elbe, the original Dutch Palace. Construction began in 1729, and when Augustus died in Warsaw on February 1, 1733, the exterior was complete in all essentials (figs. 1, 2), and there were detailed plans for the interior.

1, 2

The Japanese Palace, Dresden, ca. 1925

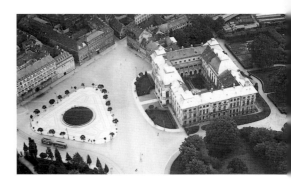

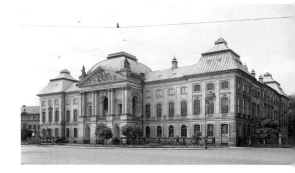

The Japanese Palace in Old Dresden, near the White Gate, formerly belonged to Count von Flemming, who sold it to the king for a hundred thousand thalers and thereby gained about twenty thousand thalers. The quantity of local and foreign porcelain is indescribable, and the culinary porcelain vessels alone are estimated to be worth a million thalers. In one of the upper rooms are seen the forty-eight large vessels made of blue-and-white porcelain for which the king of Poland gave the present king of Prussia a regiment of dragoons. (Keyssler, 1751)

FURNISHING THE JAPANESE PALACE AS A "PORCELAIN PALACE"

In the early stages of the project, Augustus the Strong was already writing notes on the plans for the ground floor and upper floor about the placement of his collections of Meissen and Oriental porcelain. These entries, for example, *Krackt Porzelain* (Kraak porcelain), point to two important features. First, they show that the Oriental pieces in the royal collection were divided into groups according to color and provenance – long before the classifications established in the nineteenth century. Second, they make it evident that the ambitious expansion of the building was designed solely to display the royal collection, for most of the king's handwritten entries relate to all the rooms on one floor. Despite this, one cannot consider it a museum in the modern sense.

The extraordinarily ambitious nature of the project becomes clear when one considers that, while most German princes in the first half of the eighteenth century set up finely furnished porcelain cabinets, none but Augustus the Strong had collections that came anywhere near to filling thirty-two rooms in a palace into tightly packed cabinets and galleries. The intended splendor of the furnishings is attested to by two series of detailed

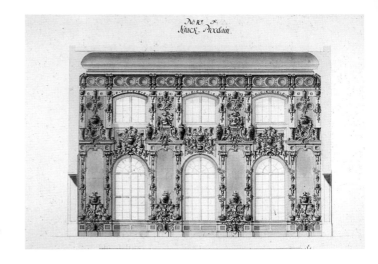

3
Design for a wall
in the Japanese Palace,
Dresden, 1729

elevations, one comprising twenty-nine fine pen drawings for the rooms on the upper floor. Made in 1729, shortly after construction began, these can be attributed to the circle of Matthäus Daniel Pöppelmann, the royal architect (fig. 3).[1] Each sheet indicates the group of porcelain pieces assigned to a particular room, together with richly carved and gilded consoles, expensive wall coverings, and lacquerwork.

A year later these designs were set aside due to a change of plan. In 1730 Augustus the Strong decided to house the Oriental porcelain in the ground-floor rooms and to reserve the upper floor for works from

his own factory at Meissen. It is not only the entries in the floor plans that reveal this new placement of the royal collections: Johann Georg Keyssler, describing a visit he paid to Dresden in 1730, recorded what kind of Meissen pieces Augustus the Strong wished to move to the rooms on the upper floor.[2] He said nothing about the ground floor. How the king envisaged the ground-floor rooms is evident from a list drawn up in 1733. It details the materials and coloring appropriate for the interior decoration of the cabinets containing particular groups of Oriental pieces; thus, it is a record of the state of planning for the heir to the throne after his accession.[3]

The second room is to contain many kinds of porcelain colored celadon with gilding, and the walls are to be provided with mirrors and other ornaments. The third room will be furnished with porcelain colored bright yellow with gilding. The fourth is a hall in which dark blue porcelain decorated with gilding will be displayed. The fifth room is to house porcelain colored purple with gilding. (Keyssler, 1751)

1 Sächsisches Haupt-Staatsarchiv Dresden (SächsHStA), OHMA Pläne und Zeichnungen Cap. II, 15.26–15.27
2 Keyssler, 1751, pp. 1319–21
3 SächsHStA, OHMA Pläne und Zeichnungen Cap. II, annex C; publ. in Sponsel, 1900, pp. 19f
4 Betriebsarchiv der Meissener Porzellanmanufaktur, Meissen (BA), Iaa 19, fol. 347a–69a; copy of SächsHStA, publ. in Sponsel, 1900, pp. 30, and Cassidy-Geiger, 1996, pp. 119–30. The translated list is reproduced on the inside back cover of this catalogue
5 SächsHStA, OHMA Pläne und Zeichnungen Cap. II, 15.5–15.25
6 Hanway, 1753, vol. II, pp. 226f

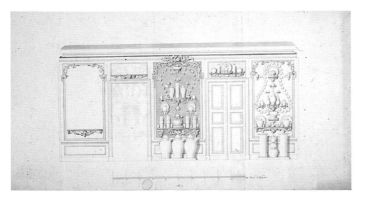

4

Design for a wall
in the Japanese Palace,
Dresden, ca. 1733

Augustus the Strong's son and heir, Elector Frederick Augustus II of Saxony – who became King Augustus III of Poland in 1734 – seems to have had no wish to change his father's plans for the upper floor. A detailed order list delivered to the Meissen factory on November 26, 1733 – six months after his accession – assigned no fewer than 25,215 porcelain pieces to the same color groups and rooms as Keyssler had recorded in 1730.[4] For the ground floor, where most of the Oriental pieces were already on hand, he had a new system of wall decoration devised by Zacharias Longuelune, one of his architects. The Chinese and Japanese pieces were still allocated to certain rooms, but Longuelune's scheme completely abandoned Oriental lacquer panels and silk and paper wall coverings. The designs he produced between 1733 and 1735, of which seventy-one elevations and details are preserved in the Dresden State Archive, show an almost museum-like arrangement of the pieces in formal symmetrical configurations (fig. 4).[5] The optical unity created by the porcelain object, its mount, and the wall, originally developed by Pöppelmann,

was abandoned in favor of an emphasis on individual pieces.

In subsequent years the Meissen factory was urged to meet the huge number of orders it received; nevertheless, the rest of the furnishing was carried out in a rather desultory fashion. When the project for the Japanese Palace was finally abandoned in about 1740, hardly a single porcelain room had been completed. The description of the palace given by Jonas Hanway, recording a visit he paid to Dresden in 1753, shows clearly that this palace, once Augustus the Strong's showpiece, had become a furniture depository for the court.[6]

THE JAPANESE PALACE IN THE CONTEXT OF DRESDEN

What was Augustus the Strong's real intention? What induced him, in about 1725, to turn the small Dutch Palace by the Elbe in Dresden Neustadt, at great expense, into an uninhabitable building whose structure bore no comparison with any other in Europe?

To find the answer one must return to a sketch of ideas made nearly ten years earlier. In about 1716 Augustus designed

a system in which particular themes were assigned to the royal palaces in and around Dresden. The system's chief aim was to outline a program in which his Saxon heartland would be turned into an ideal garden (or park) landscape. Within this scheme, Schloss Moritzburg was to be a temple of Diana; other buildings were to take on the character of a her-mitage, a knight's estate, or a belvedere. This overall plan, which was in essence Baroque, also determined the interior design of the buildings and their role within the system.

The elector-king continued to think about his palaces within a conceptual framework, evident from the ways in which the animal world is represented on the grounds of the three royal palaces: Moritzburg, the Zwinger, and the Japanese Palace.

When the king died in 1733, the interior decoration of the hunting lodge at Moritzburg was characterized by two conspicuous features: first, nearly all the reception rooms were lined with leather wall coverings; second, antlers from the royal collection were to be seen every-where. Both these features – the hides and the antlers – were trophies in the broadest sense of the word. Moreover, the palace was surrounded by various animal reserves and menageries. The live animals, caged and put on display, sug-gested the devastating – or merciful – power of the king. The animal gallery in the Dresden Zwinger, that is, the collec-tion of stuffed native and exotic animals, feathers, bones, monstrosities, etc. – the real building blocks of nature – alluded to the ruler's knowledge. And the Meissen porcelain menagerie in the Japanese Palace bore witness to the king's high culture and taste.

A comparison of the last two buildings sheds further light on Augustus the

5

Strong's intentions regarding the Japanese Palace. Standing opposite one another and separated only by the Elbe, their common features were striking. The roofs of both were to be painted blue; both contained royal collections and were more suited to festivities and show than to residential use. From the bridge over the Elbe, both could be seen at once; it was therefore hard to avoid direct comparison. Finally, their architecture suggested what they contained. The vegetal appearance and playfully ornate variety of the Zwinger, which was built as an orangery, the rich decoration in the form of fruit and flowers, the courtyard that resembled a garden, and the faunlike herms – all had a certain affinity to the collections of natural history inside the building. The classic, geometric structure of the façades of the Japanese Palace, the exotic pagoda roofs of the corner pavilions, the lambrequins over some of the windows, the paved courtyard resembling an interior room (it was to be paved with marble), and its herm pilasters, which took the form of paunchy, grinning pagods, indicated that the palace housed

exotic art collections. Thus, the realms of nature and culture – to use our modern classifications – were both represented in the royal buildings.

The monarchical pretension that lay behind this system becomes even clearer when one takes a closer look at the layout of the upper floor of the Japanese Palace. All four wings were divided into a series of cabinets and halls that obliged the visitor to walk through all of them with no possibility of escaping into a corridor. He first entered the large gallery facing the city, where a veritable menagerie of porcelain animals awaited him. Following that were five cabinets, each different in color scheme and richly adorned with Meissen porcelain. Finally he entered the long throne gallery in the wing facing the Elbe. In this last wing, behind the throne, there were to be a dining room, a retiring room, and other rooms, to which only select members and guests of the court were admitted. From here visitors could also enter the royal bedchamber, with its much admired furnishings consisting of exotic bird feathers woven together in the manner of a textile.

Opposite this, on the other side of the staircase of the old Dutch Palace, was the chapel.

This floor plan had nothing to do with the floor plan of a pleasure palace – a category that normally includes small porcelain palaces – which would have had more intimate and directly interrelated rooms, affording a respite from strenuous court ceremonials. Rather, the Dutch Palace represented, in its architecture, the quintessence of a residential palace. This is most evident in the upper story: the large gallery as guard hall and, connected to it, the five cabinets as antechambers, forming an enfilade, then the large throne room, and finally, the grand bedchamber. These were central features of a residential palace and essential for the proper conduct of court ceremonials.

The hierarchy of the antechambers, whose importance increased the nearer they were to the audience chamber, depended not on the richness of the furnishings but on the basic colors of the individual groups of porcelain they contained. In his book on painting (which was familiar to all artists of the

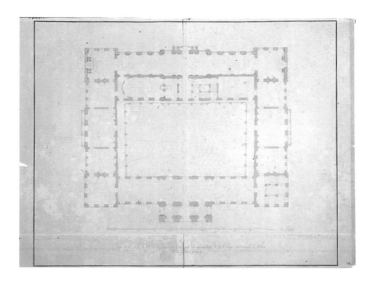

6

5
Plan of the
upper floor of
the Japanese Palace,
Dresden, ca. 1730

6
Monkey, Kaendler,
1731,
H. 47.5 cm,
Amsterdam

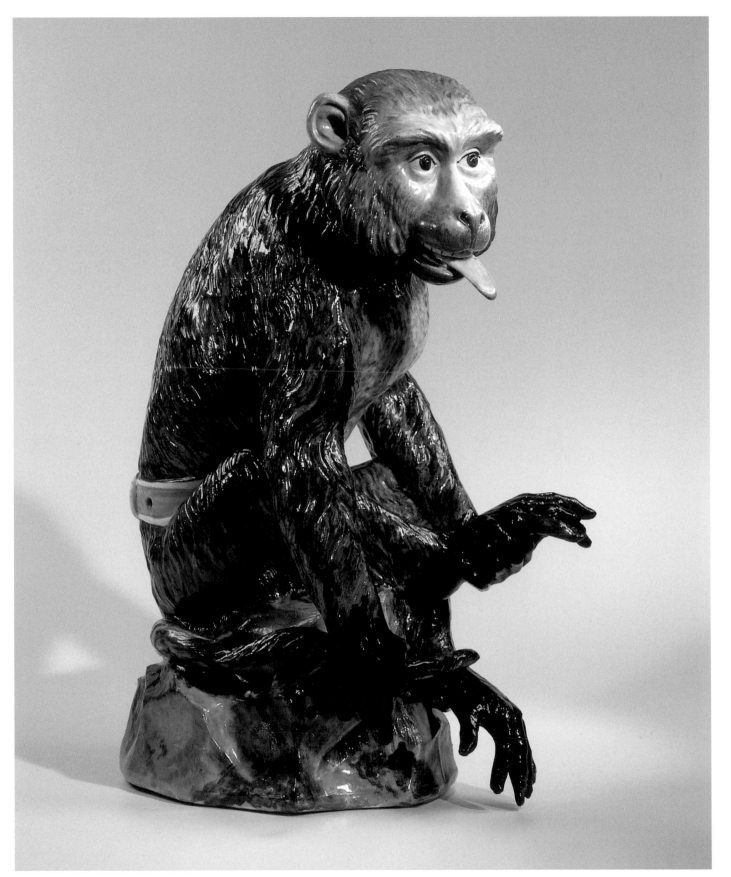

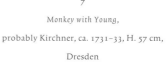

7

Monkey with Young,

probably Kirchner, ca. 1731–33, H. 57 cm,

Dresden

period), Gérard de Lairesse laid down the
following color associations: red stood
for power (for example, the power of
love), green for humility, yellow for
splendor and glory, blue for divinity,
and purple for authority.[7] Applied to the
sequence of rooms in the east wing of the
Japanese Palace, this resulted in a struc-
tured hierarchy. After leaving the animal
gallery, the visitor entered the red room,
where he prepared himself to argue his
case and hoped to be graciously received
by the prince (see fig. 5). According to the
position he occupied in court society, he
could proceed more or less far through
the stages of humility and glory before
reaching the room in which the divine
nature of the prince was expressed by
the color blue. If he was finally granted
an audience, he would first enter the so-
called Glockenspiel Pavilion; its purple
porcelain made him aware of the absolute
authority of the ruler, who sat enthroned
at the other end of the long gallery.

Bearing this in mind, consider the
statement made by the iconographic
program: it began with the large-scale
pediment relief (which still survives) over
the entrance portico, in which envoys
from the porcelain-producing lands
presented their treasures to Saxonia as she
sat enthroned, and culminated with the
ceiling painting in the throne room, in
which Minerva awarded the prize to Meis-
sen porcelain. Here we find three levels of

meaning for the Japanese Palace. First the palace presented itself as the place where the king's collections of Oriental porcelain and works of art were kept; thus, with the Zwinger, it stood for the taste and impressive wealth of the elector-king. On a second level, the theme of the program was the competition between Meissen and Oriental porcelain; on the basis of this example, Saxony's economic and commercial superiority was to be impressed upon the visitor. Finally, on a third level, which encapsulated, as it were, the conceptual nucleus of the building, the palace revealed itself as the model of a modern princely residence, one that Augustus the Strong had for various reasons been unable to build in Dresden.

HUNTING AND THE KEEPING OF ANIMALS AT THE DRESDEN COURT

When considering the large animal sculptures produced at Meissen, it makes sense to take a brief look at the different ways in which animals played a part at the Dresden court. The most important interaction between the court and the animal world was represented by hunting, various forms of which were practiced intensively. Grand hunting festivals, with their chases and battues, often lasted for several days and were sometimes specially stage managed. They afforded particularly good opportunities to demonstrate the cultural, financial, and social power of the prince as well as his physical strength.

The elector's menageries, which were to be found on the grounds of almost all his palaces – but which were especially large and well equipped at Moritzburg and Dresden – contained both local and exotic wild animals. There the menageries could be admired by the public or used to great effect as living stage sets on cere-monial occasions. Exotic or rare animals not only demonstrated the owner's extensive influence, they also showed that he could afford their upkeep and possessed the knowledge necessary for their care. Augustus the Strong's menageries could easily stand comparison with their models in Vienna and Versailles, and in 1731-33 he even financed a scientific expedition to North Africa, from where live animals were sent back to him. His collection of animals was enlarged through gifts from other rulers and purchases from traders as well.

Yet the exotic birds and animals often did not survive for long. Accordingly, when they expired, they were handed over to taxidermists in Dresden, who prepared them for the scientific collections in the animal gallery of the Zwinger. The animal gallery also housed items such as feathers, bones, and eggs, and specimens of various kinds. In the days of Augustus the Strong, the animal gallery was already one of the principal sights of Dresden, making it clear to everyone that the relationship between the court and the animal world was particularly marked there, in both scientific and symbolic terms.

At the Dresden court there were not only live animals, but all the facets of the Baroque portrayal of animals: moral and ethical values, as expressed in animal fables; princely virtues; princely status, as represented by heraldic symbols; and allegorical references were sometimes conveyed through stylized representations of animals. Motifs relating to Paradise or Noah's Ark carried a religious message and demonstrated the wealth of Creation, as exemplified in the "society of animals." It becomes clear from these possibilities of animal representation in the Baroque age – merely touched upon here – that the animal owed its *raison d'être* solely to its function as a symbol for human values and ideas. An educated person was accustomed to seeing himself and others symbolically represented by animals. He understood that the situation in which an animal was portrayed or the emotions attributed to it were references to the world of human feeling; he would scarcely interpret these representations as objective portrayals of the animal. Only the scientific depiction of animals in contemporary zoological illustrations (which, of course, had nothing to do with court display) was concerned with the animal itself, its characteristics, and its habitat.

These opposing tendencies must not be forgotten when looking at the animals with which Augustus the Strong chose to populate the Japanese Palace. As in each of his important palaces, there was to be a collection of animals, but in this case, in accordance with the plan for the building, they had to be made of porcelain.

PORCELAIN ORDERED FOR THE JAPANESE PALACE

Although planning for the reconstruction of the Japanese Palace began in about 1725, the earliest documented evidence of porcelain being ordered for the palace dates from 1728. One may surmise that it was only then that Augustus the Strong decided to combine his unique and extensive collection of Oriental porcelain with products from his own factory at Meissen. However, the first extant list of items ordered for the palace was drawn up on March 28, 1730. Here, too, the pieces from Meissen were intended merely to complement the Oriental pieces; the idea of creating two separate collections emerged only in the months that followed.

The surviving order and delivery lists for the Japanese Palace cover the period from 1730 to about 1740. They directly reflect the development of the project and the various phases of its conception. Some are to be taken as actual course corrections, in which the extent of the orders was changed or individual areas were more precisely defined. For example, on November 18, 1733, Count Alexander von Sulkowski, who was responsible under Augustus III for ordering supplies for the palace, had 35,798 pieces of porcelain reserved for it. A week later he signed the detailed list mentioned above,[8] which set out the precise requirements in regard to form and decoration for every room on the upper floor. It was intended for the painters, who, after all, had to know which pieces to paint and how to paint them.

As early as October 1730 Johann Georg Keyssler recorded that the large gallery on the upper floor was to be "furnished with all kinds of birds and animals, both native and foreign, made of pure porcelain, in their natural sizes and colors."[9] Yet the earliest extant order list, from March of the same year, related only to tableware. Moreover, the instruction given to the master modeler Johann Gottlieb Kirchner (born 1706), who was reappointed to the factory on June 1, 1730, mentions only particularly large vases and other vessels for which he was to make the models. So one may infer that the plan for a gallery with animal sculptures did not mature until the summer of 1730. This accords with the fact that this was also the time when the Meissen porcelain was allocated to the upper floor and the Oriental porcelain to the ground floor. Accordingly, the intention, already carried out, to place the Japanese Palace in the same conceptual context as other royal buildings, in particular the Zwinger, was also established in the summer of 1730.

One of the central problems the factory faced was that of finding an artist capable of producing suitable models for this unusual commission. The demand for such monumental porcelain figures was unprecedented, and there were no comparable figures made in the Orient. The struggle to achieve this technical and artistic aim, which lay only just within the realm of possibility, was one of the most important reasons for the impressive growth in the production of Meissen porcelain in the 1730s. The creation of animal figures became a challenge for the technicians and modelers and a dominant concern within the factory, as is clearly indicated by the historical records.

It was probably not until the spring of 1731 that Kirchner made his first models for large-scale animal figures. In June 1731 an assistant was assigned to him for the express purpose of working on the large animal sculptures for the Japanese Palace. This was Johann Joachim Kaendler (1706-1775), who was to become one of the great masters of eighteenth-century porcelain sculpture. Although Kaendler at once began modeling birds, the earliest surviving order list for animals is dated December 17, 1731.[10] The list was a kind of statement by the factory that recorded which models had been completed and which had not. In subsequent years the animal sculptures for the Japanese Palace were recorded by the factory and the project managers in lists of goods that had been ordered and delivered; these lists were constantly revised. Some even stated the price per model, though neither Augustus the Strong nor his successor, Augustus III, ever expected to pay for these works of art.

The first lists only occasionally name specific animals because initially the king's requirements and commands were also conveyed verbally.

10

8 See footnote 4

9 See footnote 2

10 BA. 1A.15, fol. 522ab; publ. in Sponsel, 1900, pp. 52-3

8

Vulture, Kaendler, 1734,

H. 80 cm, Dresden

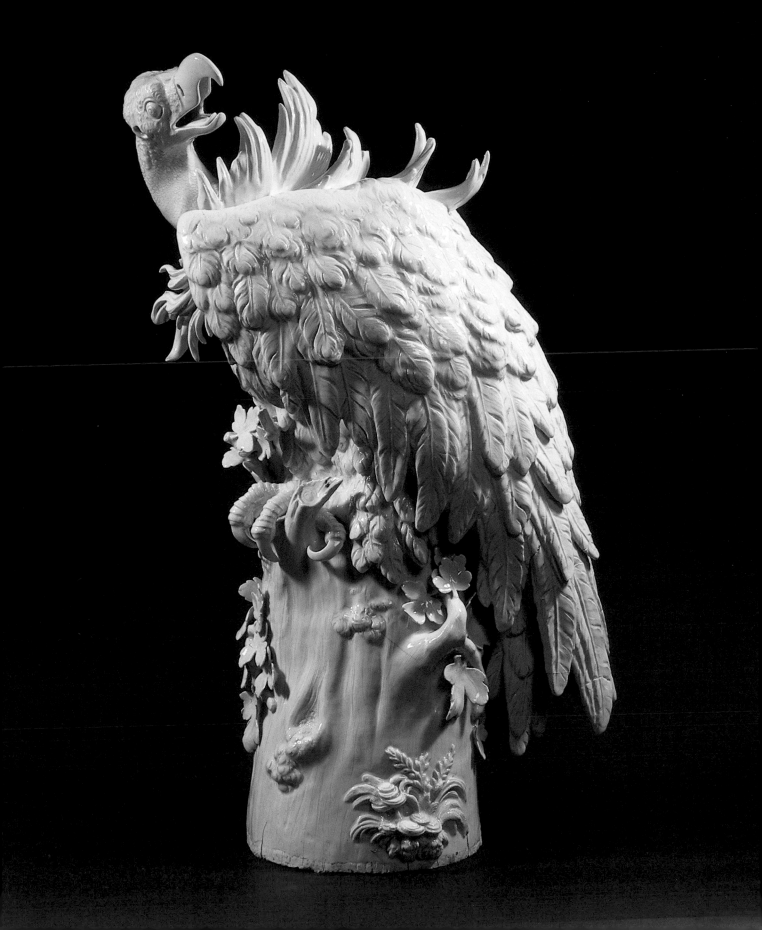

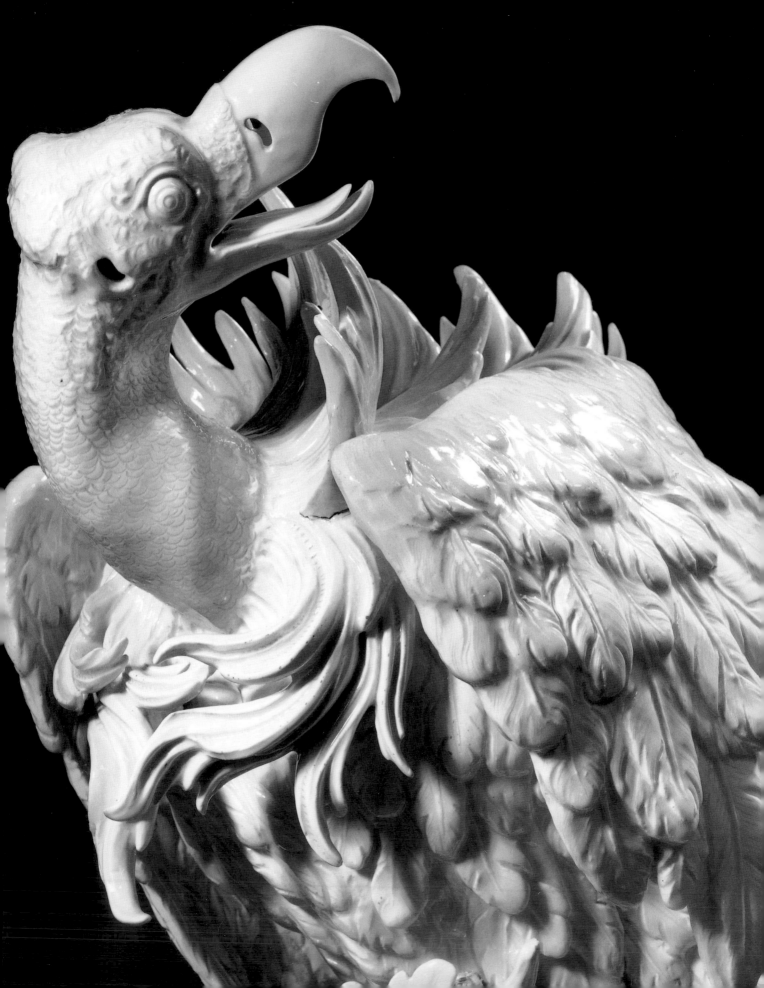

13

However, from as early as 1732 there are lists in which every animal required was individually named. The order in which they were listed – and which was retained in the following years – does not allow any conclusions to be drawn in terms of content. The only distinction is between mammals and birds; there were no sub-divisions according to size, hierarchy, or place of origin. At first, four examples were required of almost every model. The maximum requirements were reached six months after the death of Augustus the Strong in the list of November 26, 1733, already mentioned, in which altogether 37 different mammals and 32 species of bird were ordered. This meant a total of 296 porcelain mammals and 297 porcelain birds – all for a single room, the great gallery on the upper floor, facing the city.[11]

Among the requirements were native domestic animals such as the goat, the dog, and the cock; wild animals such as the fox, the bear, the squirrel, the falcon, and the bittern; and exotic animals such as the lion, the monkey, the rhinoceros, the parrot, and the cassowary. There were even three fabulous creatures: the dragon, the sphinx, and the unicorn. It cannot be said for certain who made the selection.

Reconstructing the connection between the orders and the development of the royal menageries is not difficult.

The rooms on the top story, which is to be thirty-eight feet high, houses only Meissen porcelain, and the first room is a gallery that is thirty-eight feet high and one hundred and seventy feet long. It is furnished with all kinds of birds and animals, both native and foreign, made of pure porcelain in their natural sizes and colors, and in those pieces that are already completed one cannot sufficiently admire the artistry and beauty. (Keyssler, 1751)

11 See footnote 4

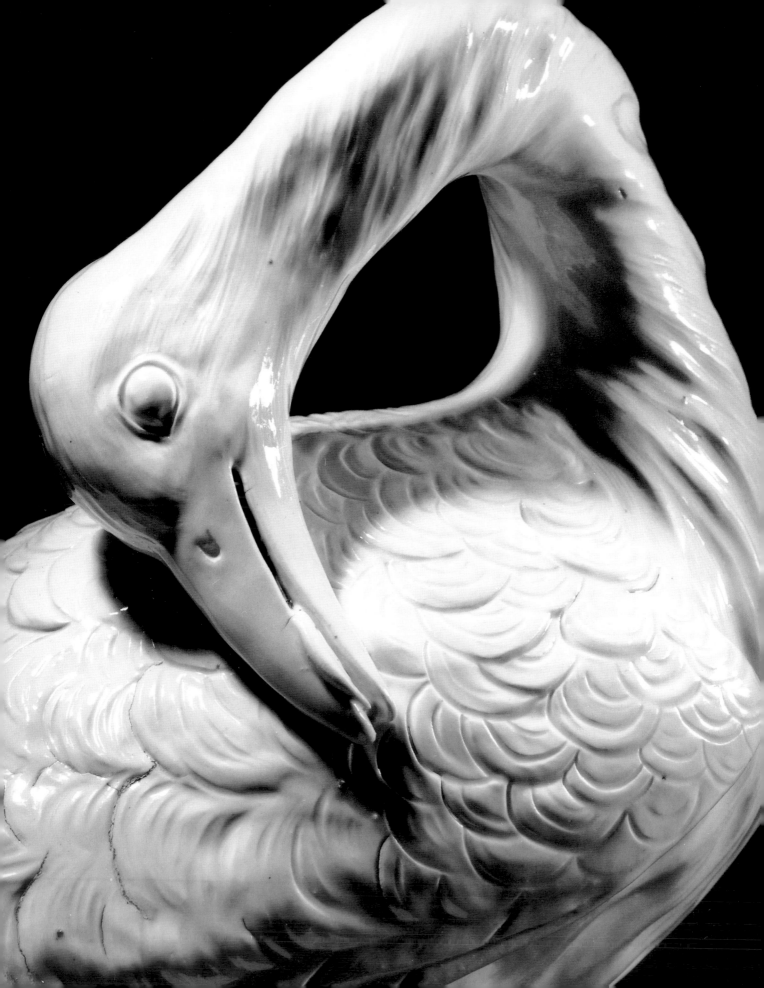

10

Parrot,

Kaendler, 1731,

H. 34 cm,

Amsterdam

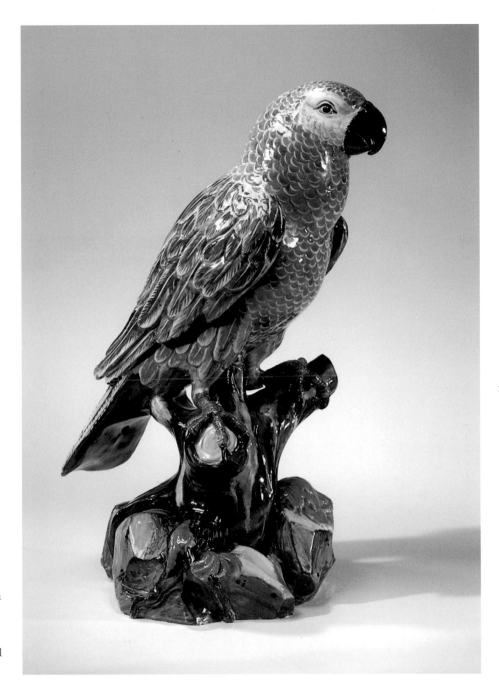

15

No sooner had a new animal arrived in Dresden than it would appear in the next order. The modelers also took it upon themselves to devise animal figures that did not appear at all in the royal order lists. This led to an interplay of real demands and additions based on artistic fascination.

Most of the animal names on the lists agree with those in common use today, while a few reflect a desire to designate exotic creatures in a way that would mean something to the recipient. These expressions relate (with a logic that is not hard to follow) to the provenance of the animal (the "African donkey" is the zebra), particular visual features, and behavioral characteristics, or else they result from the perception of parallels with native creatures (the "Indian raven" is the macaw).

The quantity of items ordered, which admittedly was somewhat reduced by the time the last surviving list of animal figures was compiled in 1736, could scarcely have been accommodated in the gallery for which they were intended.

The models demanded were not small objects, but nearly life-size figures. Although it was impossible, for technical reasons, to create life-size animal figures in all cases, the largest model, the cassowary, is 129 centimeters in height. In contrast to the other rooms in the palace, no designs have survived that show the disposition of porcelain pieces in the

animal gallery. One may assume that the animal figures were intended to stand on pedestals and wall consoles. To this extent they were not treated very differently from the porcelain vessels in the other rooms and were effective as individual works of art while contributing to the ambience of the room as a whole.

TECHNICAL PROCEDURES AND PROBLEMS OF PRODUCTION

Today anyone who stands before the large-scale Meissen animals is struck by the fact that they lack the perfection of the smaller figures. Instead of being gleaming white, most appear yellowish, and some look so gray and grainy that at first one is disinclined to believe that they are made of porcelain (figs. 11, 12). Moreover, many are covered with a fine network of small cracks or have gaping cracks near the base. All these defects show clearly that the main effort in their manufacture was directed not at achieving nuances in design but to getting the works through the production process reasonably intact.

The original model fashioned out of smooth clay had to be one-sixth larger than the final object, since its volume was reduced in the firing. Much experience and skill had to be acquired before the model could be turned into porcelain. The slightest error or miscalculation in the chain of production could destroy the piece at the final stage. It is therefore worthwhile, especially in the case of the large animal figures, to visualize the most important stages in the production process.

Once the clay model that the artist had made was cast in plaster, the right composition of the porcelain paste had to be found. The Meissen factory was barely twenty years old at the time, so this was far from easy. Not only did the artists have little experience with figure sculptures, the monumental format of these figures caused problems for the arcanists (who developed the correct composition of the porcelain paste – from various basic substances – and consequently were responsible for its behavior in the kiln). If the paste had too much flux, deforma-

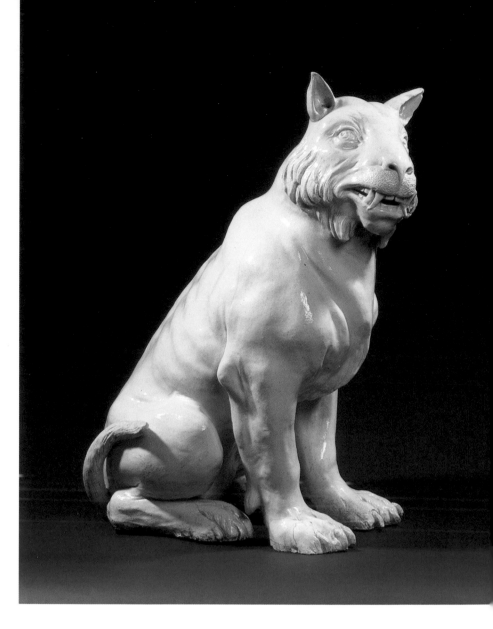

tions could occur as the object softened in the kiln; if the paste was too hard and unable to yield to the pressure of its own weight, serious cracks would appear near the base. The solution that was reached after a long, empirical search was to add ground fragments from porcelain rejects to the porcelain paste in order to give it firmness. This at first led to protests from the formers, who put the shaped pieces of a figure together with a slip and incised details into the surface. They were no

longer able to achieve the necessary delicacy in the fine tooling, owing to the grainy consistency of the paste. On the other hand, experiments with sand, stoneware, clay, and excessive quantities of ground shards led to an unpleasant and at times grainy gray or yellow coloration (fig. 13). Johann Gregorius Höroldt, the director of the factory, tried to mitigate this dirty appearance by having the figures coated with a diluted form of the "white" porcelain paste used

in the manufacture of tableware before the first firing, but this was not a particularly good solution either, as the finely worked surface became blurred and lost its sharpness. A workable filler for the large-scale figures that was accepted by everyone was discovered only in 1734, after three years of experimentation.

When the mold maker had formed the separate parts of the figure with paste from the plaster molds, the pieces, still moist, were given to the former (or *répareur*). Together with the modeler, he was the most important person in the production process. He had to give the sculpture, as far as possible, the same appearance the modeler had originally created in the clay model, which had meanwhile been cut up to make the plaster molds and was now lost. Moreover, the quality of the joining of the separate parts determined whether the join would hold during firing or would come apart because of trapped air bubbles. No less important to the final appearance of the porcelain sculpture was the way in which the former had tooled the surface: the more sharply and vividly he cut the plumage of a bird figure, for example, the clearer and more lifelike it would eventually appear, despite the smoothing effect of the glaze.

From another source, which gives detailed information about the technical difficulties posed by the large-scale porcelain figures, it is learned that one mold maker and one former worked together as a team.[12] Because several examples of each model were ordered and it was necessary first to find the logical sequence for assembling the separate parts, these small teams usually took over all the examples of a particular model. They studied the defects that appeared after firing and tried to prevent them in other examples by creating appropriate supporting constructions made of porcelain paste on the inside or by using a different form of base: a closed base, one with large apertures, or one with no base plate at all (fig. 14, detail).

Once the parts of the figure in porcelain paste had been assembled and tooled,

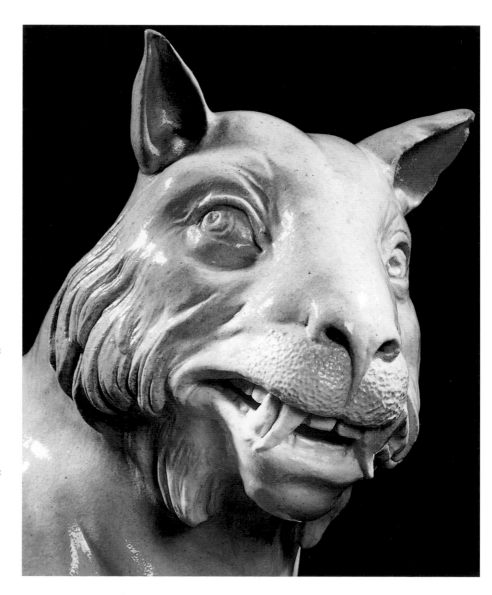

17

12 The source referred to is a roll of documents comprising the accusation, examination, and defense statements relating to the dispute over competencies that took place in 1734 between Inspector Johann David Reinhardt and the master modeler Johann Joachim Kaendler on the one hand and Johann Gregorius Höroldt, the painting director and actual manager of the factory, on the other. BA, IAe.2, IAe.3, and IAe.5

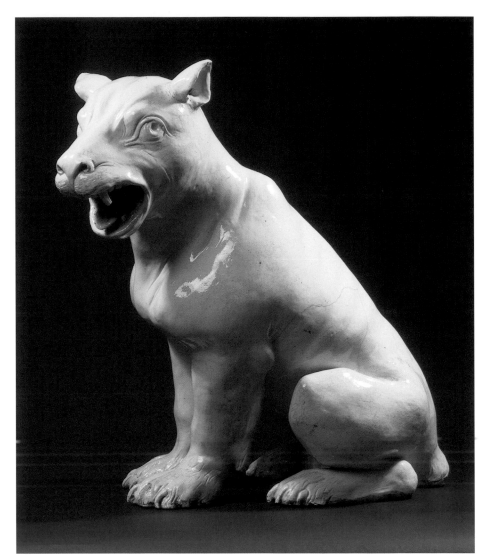

12

Leopard,

Kirchner, ca. 1732-33,

H. 74 cm,

Dresden

13

Macaw,

Kaendler, 1731,

H. 69 cm,

Amsterdam

18

bottom edge, about one centimeter high, was covered with clay (this was removed, by scratching if necessary). As a result the glaze did not reach all the way down to the bottom to ensure that when the glaze was fired, the sculpture did not adhere to the floor of the kiln.

Before 1731, that is, before the first really monumental Meissen pieces were made, tableware and smaller figures had been placed in the kiln in separate saggers (containers made of fireproof clay) to protect them from direct heat. But, as it was technically impossible to make saggers large enough for the animal figures, another technique had to be developed. The figures were placed directly in the kiln, and a protective wall of sagger tiles was built up all around them, reaching to the top of the kiln.

the sculpture had to be carefully dried in the air for up to three months, depending on its size and the thickness of the walls. Any irregularity in this procedure could lead to early damage – so-called drying cracks. After they dried, the sculptures were given their first firing, at about 800° C, to make them stable enough for the next stage.

The next stage was the glazing process, which posed further problems. Once an ideal glazing compound was discovered for such large formats, a technique had to

be developed for applying it evenly, for most of the animal sculptures were too big and heavy to be briefly dipped in liquid glaze, which was the procedure that had previously been used for the smaller vessels and figures. The solution, about which one of the arcanists wrote a detailed account, was to put the figure on a board over a tub, to pour the glaze over it from jugs, and to use sponges to cover the less accessible parts. The sculptures were not glazed on the inside. Before the glazing process, a strip along the

Detail of fig. 14

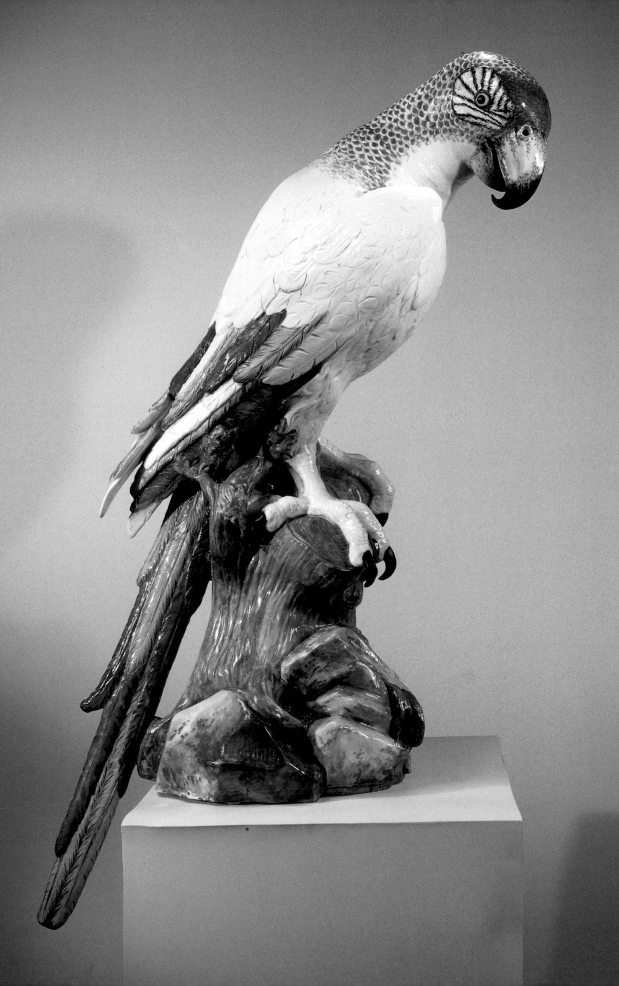

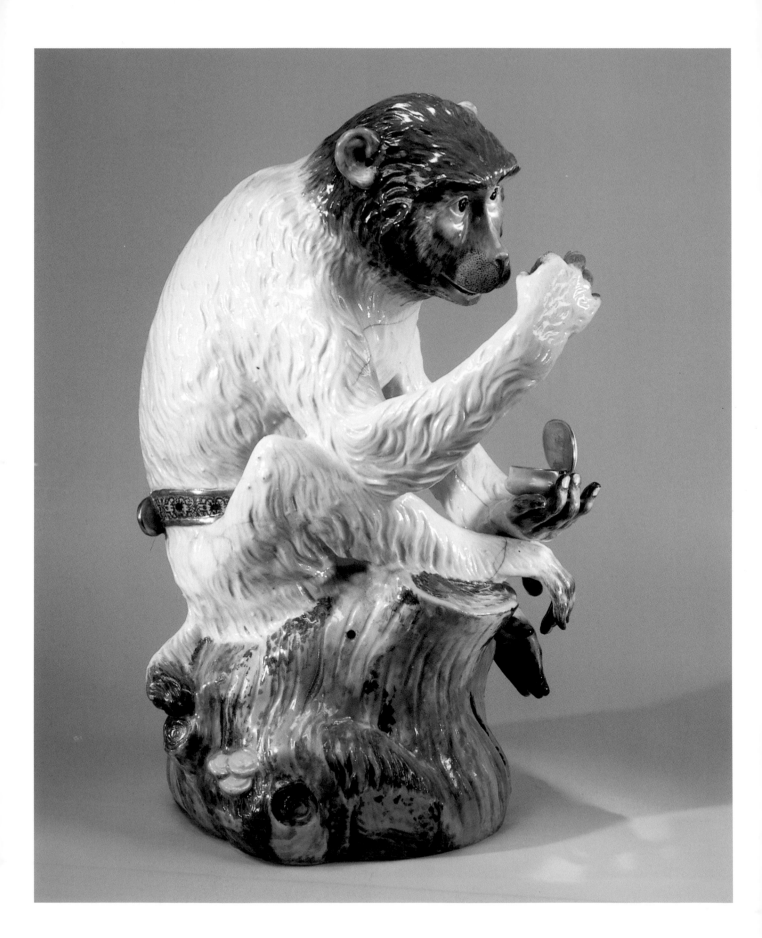

The chief problem with the subsequent firing, which ultimately determined whether a sculpture turned out well or not, arose from the considerable shrinkage it underwent when fired. During the firing, when temperatures reached about 1,400° C, the porcelain transformed, becoming radiantly white, dense, hard, and resonant. The size of the objects was reduced by one-sixth. This shrinkage and the strong downward pressure caused by the weight of the objects created cracks of varying severity in nearly all the large animal figures. The cracks often occurred only around the base, but sometimes they formed a network over the entire surface. For the sake of stability it was sometimes necessary to fill the large cracks with cement. Despite the efforts of the arcanists to reduce the formation of cracks by improving the quality of the paste and the kiln equipment, many of the animal sculptures still show evidence of these technical difficulties.

One of the primary technical demands made on the artist was that he should understand how the porcelain reacted during firing and take this into account when shaping the models. In the case of a large-scale figure, he had to accommodate the endangered parts – the extremities, for instance – to the overall posture of the animal in such a way that technical requirements and artistic intention did not get in each other's way. Thus, for example, Kaendler bent the heron's neck back to create the impression of a bird preening itself. At the same time the long, slender neck – which could never have supported the head, had it been positioned upright, but would have snapped during firing – was subject to no greater technical risk than a hooped handle (fig. 16). The reeds between the legs indicated the bird's habitat while providing the necessary support for the weight of its body, which the two long legs could not do. In the case of the she-wolf baring her teeth, this function is performed by the pups (fig. 15).

Kaendler in particular, during the six years he created large-scale figures for the Japanese Palace, developed a fine feeling for the technical possibilities of the material and elegant ways of concealing its limitations. With some of his models he deliberately used the sequence of stages in the manufacture of a porcelain figure in order to produce variations, as he did, for instance, in the case of the heron, by modeling two different necks for one body. Thus, at no great expense, the original model – a heron with carp (fig. 17) – acquired a pendant, a heron preening itself (fig. 16). With other figures, such as the macaw (fig. 13), the bird's head had only to be attached at a slightly different angle and it could look either to the left or to the right.

When the animal sculpture had been glazed and undergone all the firings unscathed, it still had to be colored, for Augustus the Strong had expressly asked for animals painted in natural colors.

14
Monkey with Box,
Kaendler, 1731,
H. 49 cm,
Amsterdam

15
She-Wolf with Two Pups,
Kaendler, 1735,
H. 67 cm,
Dresden

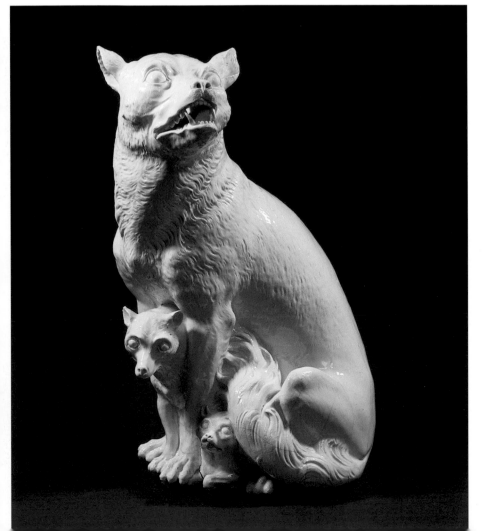

21

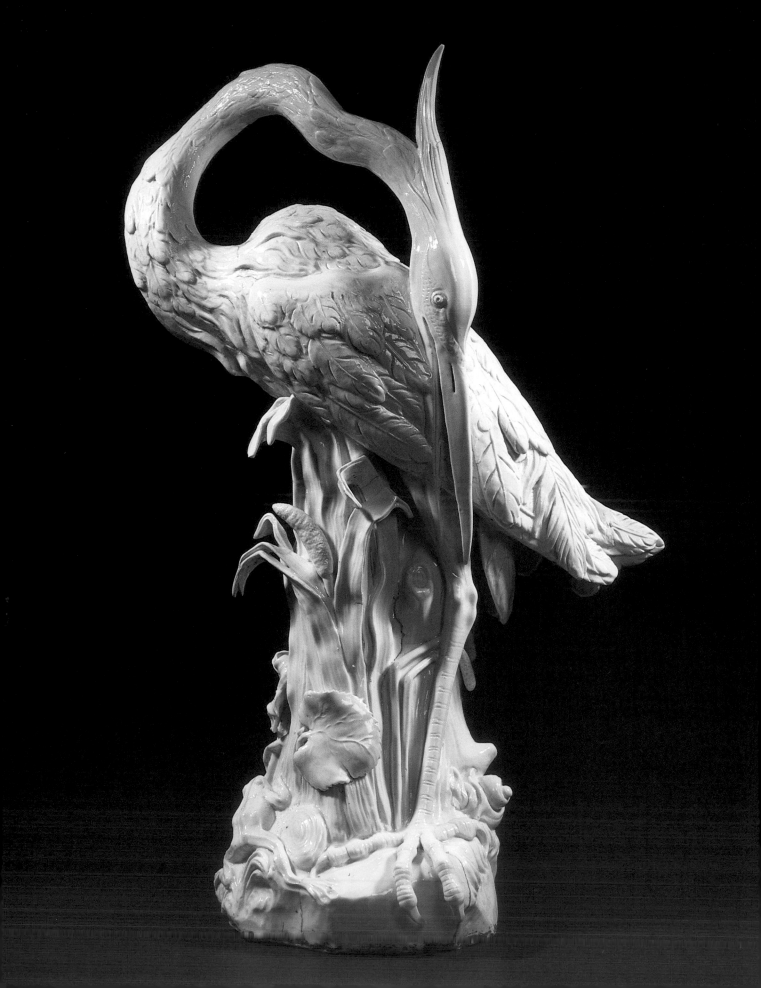

16

Heron,

Kaendler, 1732,

H. 62 cm,

Dresden

17

Heron with Carp,

Kaendler, 1732,

H. 62 cm,

Dresden

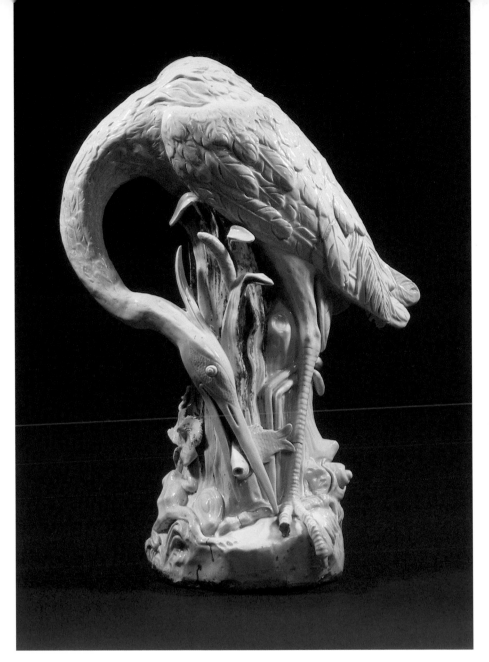

However, since almost all the large-scale figures emerged from the firing scarred by cracks, it was too much of a risk to expose them to yet another firing, which would have been necessary had they been painted with enamel colors. It was rightly feared that the figures would shatter. With the medium-size figures, such as most of the monkeys and the smaller birds, the use of this technique was relatively unproblematic. The large figures, however, were colored with oil paint, which naturally could not even remotely match the intense brilliance and the effect of depth that characterizes enameled porcelain.

From a surviving invoice submitted by Christian Reinow, the court lacquerer, it is known that he used bright colors on some of the animal sculptures but covered other figures, already colored with oil paint, with a bright varnish that was intended as a substitute for glazing. However, it cannot be stated with certainty who was responsible for the many sculptures that were already painted in cold colors when they left the factory and were delivered to the palace. Although the factory archives state that the porcelain painters were occasionally employed to paint parts of the building, they are curiously silent about the possible participation of the painters' workshop in the prestigious project of the large animal sculptures. The few figures that still display significant remnants of cold coloring have become dark and unsightly, owing to changes in the paint or the varnish (fig. 18). This may be one of the reasons why the coloring of most of the large-scale figures has been gradually washed away.

The technical genesis of the individual animal sculptures not only affected their aesthetic appearance, it was also responsible for certain marks that were scratched on some of them that have often been wrongly interpreted as signatures. These marks, for example, OXj (comprising the letter O and the Roman numeral for eleven), which is found on all the extant examples of the peacock (fig. 20), or combinations of letters and numbers on some figures of vultures, are references to entries in the arcanists' recipe books. Thus, the mark N9 corresponds to the number of a particular paste mixture in Höroldt's book of arcana (porcelain

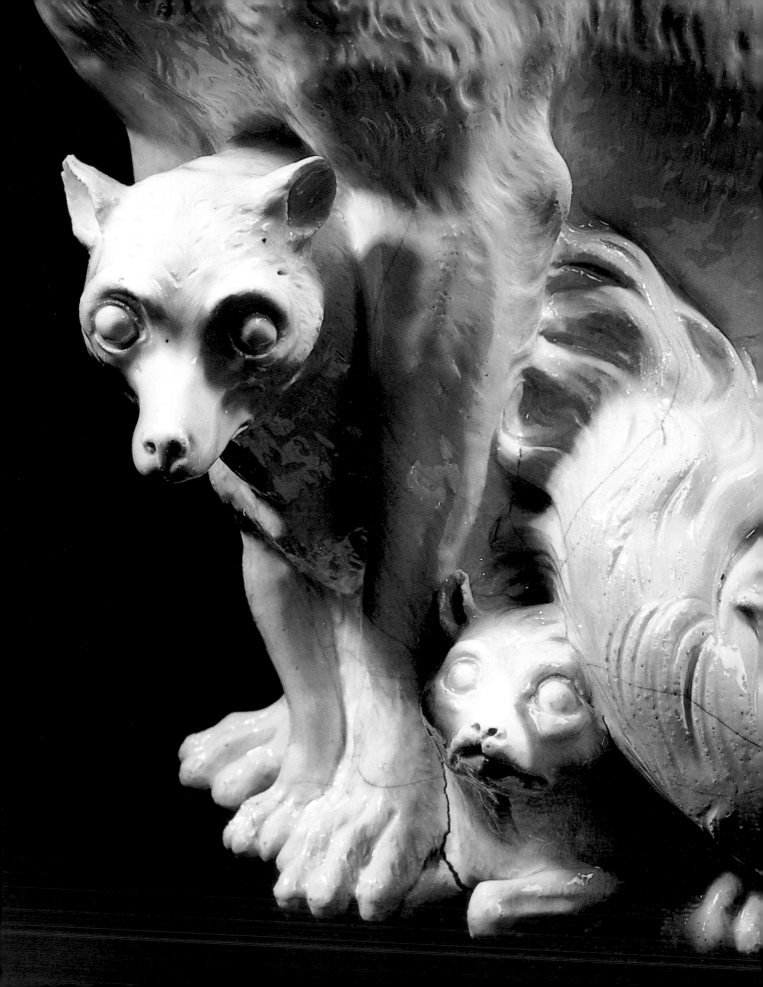

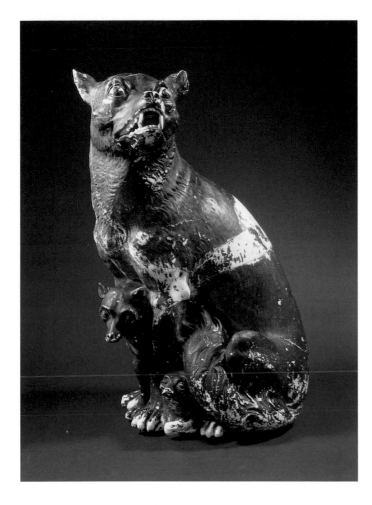

18 >

She-Wolf with

Two Pups,

with traces of the

original oil paint,

Kaendler, 1735,

H. 67 cm,

Dresden

< Detail of fig. 15

were first created to meet a royal order – regularly bear this mark, which guarantees their authenticity. There was no need to use it on the large porcelain animals, however, since these were intended exclusively for the Japanese Palace.

The inventory numbers of the royal porcelain collection, which were incised on the undersides of Oriental and Meissen tableware and then blackened for easier recognition, are merely painted on the large animal figures. Moreover, the formers' marks that were used on tableware for purposes of inspection and attribution were not needed for the large animal sculptures, as it was known in the factory which modelers and formers had made which animals. There is one exception: Andreas Schiefer carved his mark, a cross with four points, on the figure of a cat that is now in the Dresden Porcelain Collection in the Zwinger.

Since painters and formers were not regarded by the factory as artists in the modern understanding of the term, it was unusual for them to sign their works. However, hidden indicators such as initials or coded marks were used by both painters and formers. Andreas Schiefer, who must have been particularly proud of working on these figures, carved his initials in a hidden place on the figure of a bustard. An additional peculiarity is presented by a large figure of a vulture in

25

recipes), which has an added note to the effect that it was the best one so far for large-scale figures. The marks are easy to explain if one considers that the models had to be dried in the air for two to three months before firing, but that, meanwhile, experiments with paste and the production of other figures continued apace. After firing, it was possible, with the help of this inconspicuously placed coding, to check whether the paste mixture that had been tried some weeks before had led to an improvement in regard to the purity and whiteness of the body and the formation of cracks.

In the case of smaller models, where there were few problems with the paste mixture, a different kind of marking is occasionally present on the underside of the base. For example, the parrot (fig. 10) and the white-collared monkey (fig. 22) from the Rijksmuseum have the letters AR in underglaze blue; this mark is also found on items of tableware and stands for Augustus Rex, indicating that these are royal pieces. More rarely, the best-known of the Meissen marks, the crossed swords, was applied to medium-size animal figures. The small birds that could also be bought freely from the mid-1730s onward – though their models

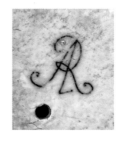

Detail of fig. 10

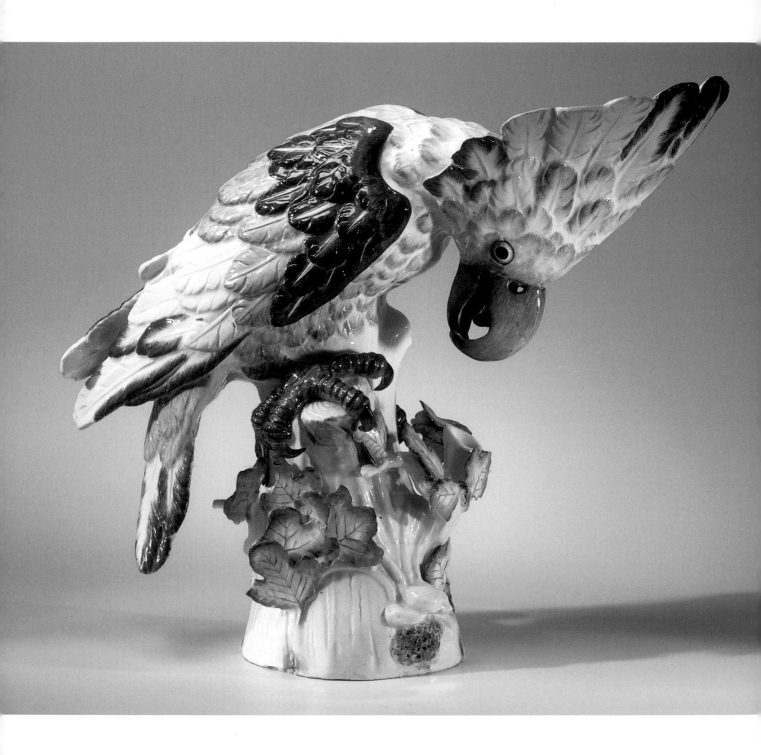

a private American collection that even carries a date on the inside of the base, the day on which the investigations and examinations connected with the above-mentioned dispute between Höroldt and Kaendler came to an end (see footnote 12).

This was a decisive point in the daily routine of the factory employees. The struggle for success in the manufacture of large animal sculptures demanded maximum output after the king's order of 1730. Nothing comparable had ever

been produced in Europe before, and it resulted in huge technical advances until the plans were abandoned by about 1738. Invaluable experience also was gained with regard to the artistic possibilities of the material as a plastic medium.

19

Cockatoo,

Kaendler, 1734,

H. 34.7 cm,

Amsterdam

20

Peacock,

Kaendler, 1734,

H. 118.5 cm,

Dresden

THE ARTISTS AND THEIR MODES OF PERCEPTION

Three modelers were involved in designing the animal sculptures for the Japanese Palace. Johann Gottlieb Kirchner, Johann Joachim Kaendler, and Johann Friedrich Eberlein. Eberlein did not create many sculptures and was artistically very much under Kaendler's influence, so we will not discuss him.

Johann Gottlieb Kirchner was the first modeler to be given a firm appointment by the Meissen factory. This was in 1727; the factory had previously used models bought from other artists or casts of Oriental sculptures from the royal collection made of porcelain or carved soapstone. At first Kirchner found it hard to become accustomed to this treacherous material, though it was probably for personal reasons that he was dismissed in the following year. His successor, Johann Christoph Ludwig Lücke, was also unable to meet the aesthetic requirements of the factory management. Then, faced with the pressure of orders for the Japanese Palace – for tableware, not yet for animals, but also for monumental vases with sculpted ornamentation – the management had no option but to reappoint Kirchner, who at least had the necessary

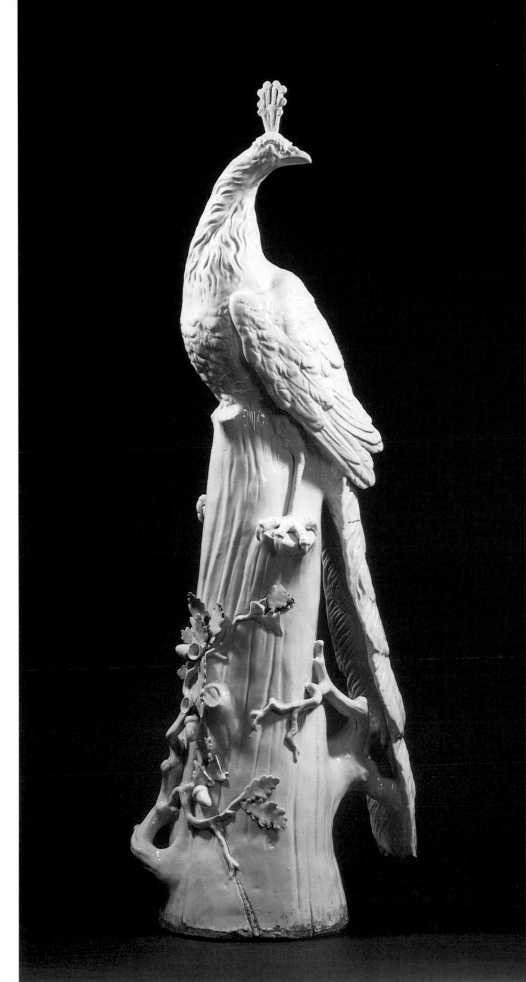

technical knowledge and therefore returned to work as a modeler. It soon became clear, however, that Kirchner could not cope with the increasingly extensive orders by himself, especially since the large-scale animal sculptures posed a particularly delicate task: combining artistic quality with mastery of the technical requirements.

It is an open question whether a search then began for another suitable sculptor or whether word simply spread that the management needed a new artist to deal with the orders for animal figures. In any event, the Dresden sculptor Johann Joachim Kaendler modeled a sample clay figure of a heron after a live model. Augustus the Strong seems to have been so pleased with it that he issued a verbal command for the young sculptor to be summoned to the factory, where, beginning on June 22, 1731, he was to devote himself, as Kirchner's immediate subordinate, to the modeling of large-scale animal figures. What Kaendler's sample piece looked like is not known, but the description he gave in 1735 in connection with a retroactive demand for money suggests that it closely resembled the model he made in March 1732 in response to an order for the Japanese Palace (fig. 17).

It is astonishing how quickly Kaendler mastered the porcelain medium, which was for him a new material. He later said that Kirchner – as well as his father-in-law, the Dresden faïence master Eggebrecht – had familiarized him with a few basic conditions. In the summer of 1731 he created a rapid succession of bird models, starting with a large and highly promising eagle flapping its wings (fig. 23). Apart from this single figure, the birds that Kaendler modeled in this period are characterized by a curious stiffness of posture that is otherwise foreign to his work (fig. 21) because at first he relied on

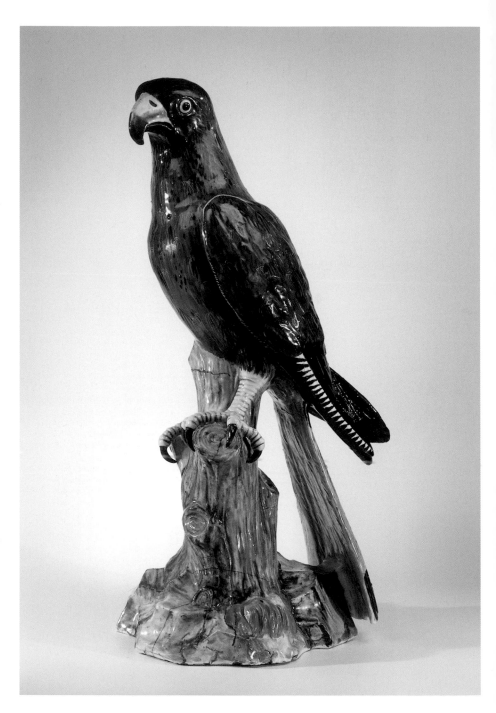

prints in zoological works. Perhaps most instructive in this connection is the large macaw, which Kaendler modeled between October and December 1731 (fig. 13). The circular bulge around the bird's eye is the result of interpreting a graphic represen-

tation in which this area, which is naturally light colored, was set off by hatching or color. Since the sculptor had to differentiate in plastic rather than color terms, he was obliged, in order to remain faithful to the archetype, to reproduce

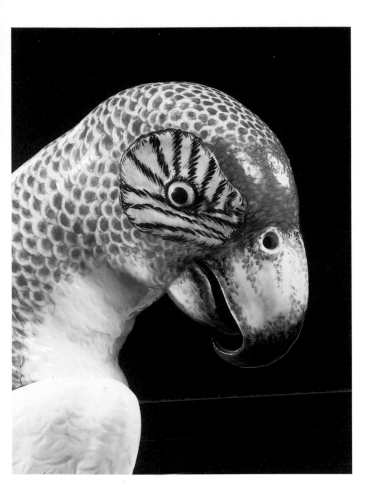

dimensional figures out of two-dimensional prototypes.

The same was not true of Kirchner, who, until he was finally dismissed a second time in 1733, was primarily concerned with mammals and had a completely different approach, which owed much to the traditional portrayal of animals. His figures do not document the nature of the animals they represent in any scientific sense; instead, they

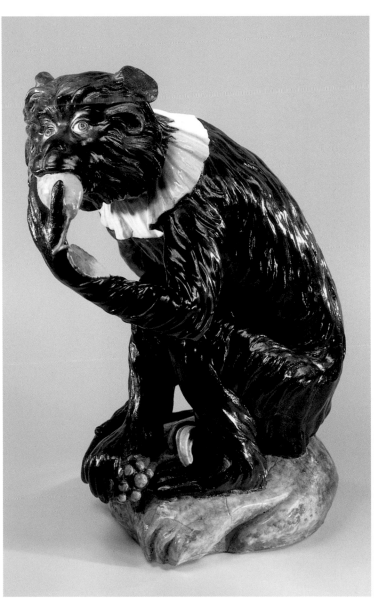

such areas by means of relief. However, after seeing and sketching live macaws in the menageries of Moritzburg and Dresden, Kaendler returned to the theme in May 1732 and created, in the figure of a macaw climbing downward, one of the most marvelous animal sculptures of all (fig. 24). The area around the eye is now true to nature.

All the animal figures that the young modeler created from 1732 onward resulted from detailed studies of live – or, on occasion, stuffed – animals in the royal collections. Since all the animals the king ordered – except the rhinoceros and the elephant – could be seen in Dresden or its environs, Kaendler no longer had any reason to create three-

illustrate the position accorded to them in the human view of nature. This is evident in the case of the lion, which in animal fables and Baroque writings is always the king of the animals. As Kirchner could not simply provide the lion with a crown and scepter to signal its kingship, he had to endow his sculpture with the physical expression and attitude that were generally associated with the epithet *regal* (fig. 26). He chose a facial expression in which the eyebrows are arrogantly raised and at the same time severely knitted. The result is entirely anthropomorphic. The lion's posture is not only inauthentic, it is quite unnatural. The natural lion twitches its tail slightly as a sign of attention, but in Kirchner's figure the tail is tucked between the back legs; the paws are neatly placed one above the other, not folded back, as is common with lions. Kirchner's lion thus shows a king of the animals that is as much in control of his posture, his movements, and his emotions as a human king should be. In Kirchner's version one of the lion's chief physical features, its mane, is more like a rather tousled full-bottomed wig than a real lion's mane. This way of giving plastic form to interpretations, not to objectively observed

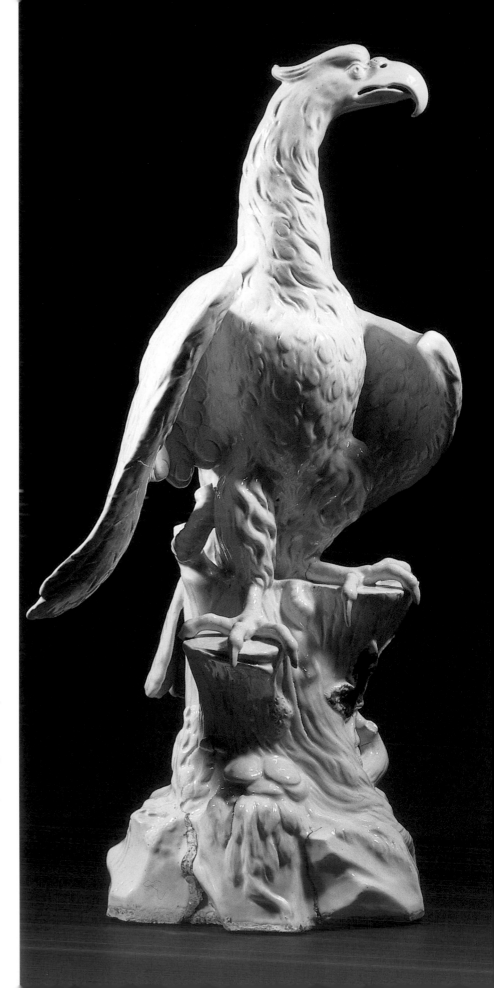

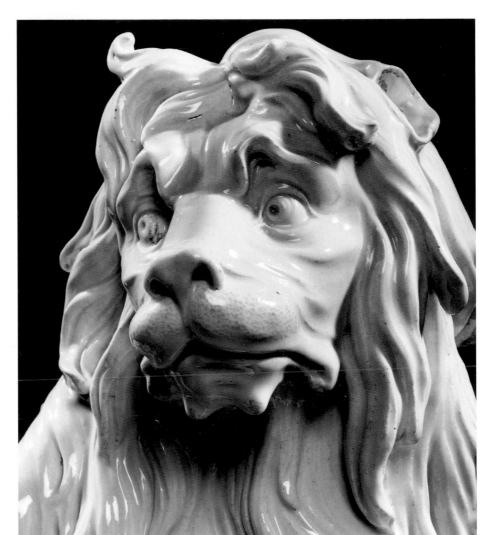

31

characteristics, together with the anthropomorphism it engenders, is to be observed in all Kirchner's models and is one of the main features of the High Baroque portrayal of animals.

If Kirchner's approach came at the end of a period dominated by a particular attitude toward nature – a view that did not necessarily require profound study, but could also draw upon traditional artistic representations – then Kaendler represents the new generation. His animal sculptures clearly indicate a change of direction that took place in the second quarter of the eighteenth century, not only in art, but in other spheres, such as natural science. No longer working from graphic archetypes, but from his own studies in the royal menageries and the animal gallery, Kaendler tried to express the essential nature of an animal. In regard to its physical appearance, he adhered largely to what he observed, but now and then he stressed a certain detail in order to draw the viewer's attention to those features. His sculptures have the effect of snapshots taken of the natural archetypes, and his animals, unlike Kirchner's, often seem quite unconcerned with the viewer or with conveying a mes-

sage. The viewer becomes an observer who confronts the work of art in the same way the modeler confronted the animal. For instance, the figure of the mother goat devotes herself to her newborn kid with the same physical intensity as the kid devotes to its mother's teats (fig. 28). True, when the figures are correctly aligned, the mother's eyes are fixed on the billy goat (fig. 29), a form of communication that could perhaps be described as psychic intensity, a complement to the physical intensity in the mother-child relationship.

The extent to which Kaendler's animal figures for the Japanese Palace are worked out artistically to the last detail and yet represent nothing but the animal itself, without any moral, ethical, or cultural connotations, may be demonstrated by a brief study of a single sculpture.

AN EXAMPLE: KAENDLER'S BITTERN

In March 1735 Kaendler made the following entry in his working reports: "A Palace piece called the Bittern is curious to behold because of its highly feathered neck and other features; it is represented sitting among reeds, such as commonly grow in ponds" [13] (see fig. 25). Kaendler's description of his new model already shows how important the various details were to him, and the surface of the sculpture itself is correspondingly varied. The simple oval base is covered by a shallow relief consisting of overlapping three-lobed scales. This motif, representing seaweed, was certainly familiar to Kaendler, judging from the settings of his earlier works, for instance, the edge of the basin of the nymphs' bath in the Zwinger. Above the base rises a thick cluster of flat, wide reeds. At the front and rear, the reeds have been cut away so that only two clusters can be seen. The bird stands over vertically grooved reeds, its wings resting on its body, its feathers in low relief. Its long neck rises up from the front of the body with wide-fanning, ruffled feathers, ending with the little head and the long pointed beak – features determined by the bird's actual appearance in nature. Other animals show a greater variety of such effects, yet the degree of plastic emphasis and sharpness of delineation was consciously chosen by the artist.

In the case of the bittern, Kaendler made use of the bird's natural habitat. The reeds between the legs provide the

32

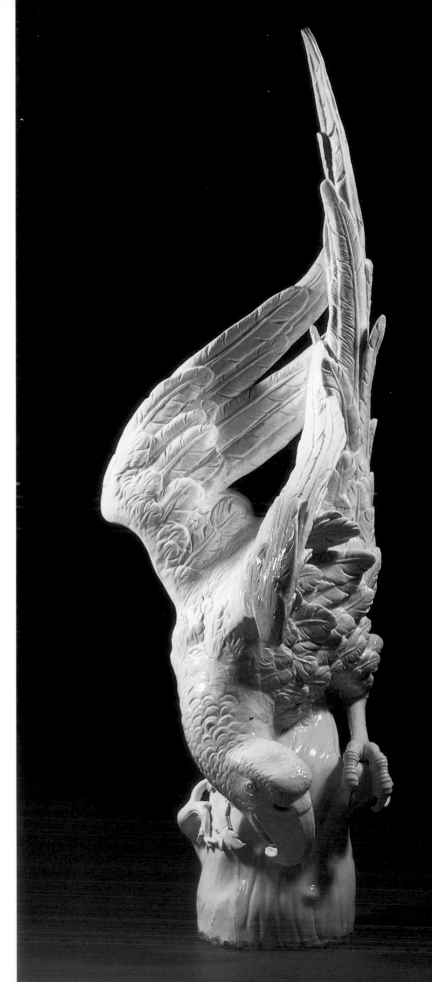

13 BA, 1Aa.24, fol. 108a

necessary support for the bird's body and at the same time playfully conceal it. In designing the surface Kaendler created a parallel between the structure of the base and that of the bird. Looking at the base in isolation, one sees at the lowest level a bulky mass with a relief pattern; from this, a zone emerges in which individual elements push in front of one another – forming a background that suggests depth and volume – before finally freeing themselves from the mass and attaining full plasticity. In the same way that the individual elements of the seaweed assert themselves – separating and developing in space – so too do the individual feathers separate from the bird's plumage on the body and neck. Applied to the medium of sculpture, this amounts to a development from designation to definition, from implication to illusionist imitation.

With the bittern, the structural parallelism results in an especially close link between the base and the figure. The design of the base suggests an essential anatomical feature of the principal motif, so that the eye, as it moves to and fro between these two most conspicuous areas – the tips of the reeds and the neck of the bittern – does not realize the problematic nature of the link, or ignores it.

Most of the porcelain mammals are portrayed lying down, a few are sitting, and three are standing: Kirchner's rhinoceros and elephant, and Kaendler's aurochs fighting a wild boar.

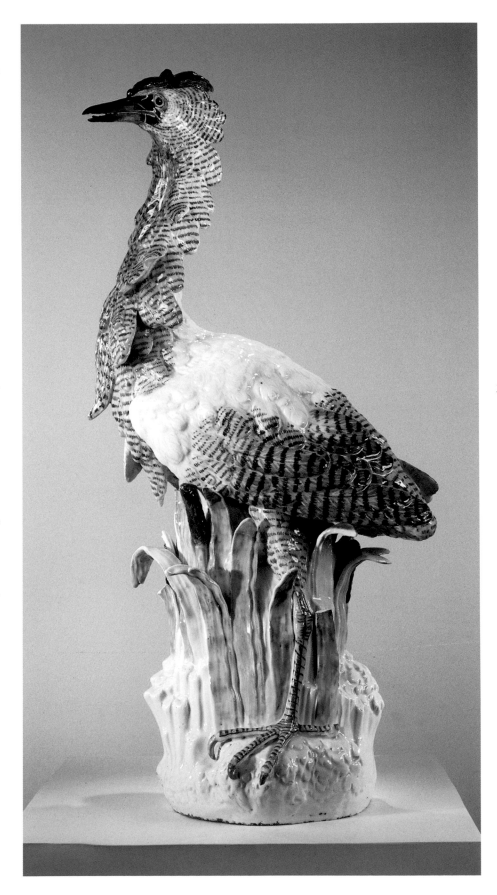

33

24

Macaw,

Kaendler, 1732,

H. 121.5 cm,

Dresden

25

Bittern,

Kaendler, 1735,

H. 68 cm,

Amsterdam

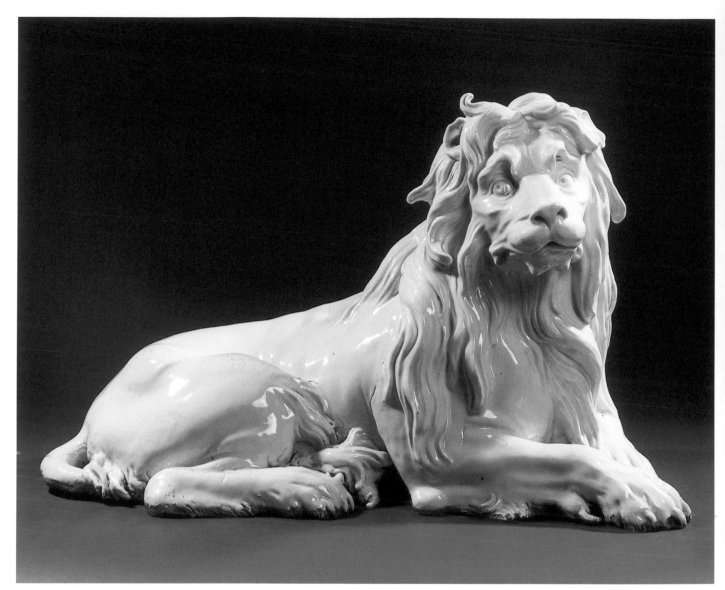

Given the large area that the animals occupy when lying down and the fact that they are aligned horizontally, there is technically no need for a base plate. When the animals are sitting, it is mainly the strength of the front legs that determines whether they could survive shrinkage in the kiln without being deformed. Except for the monkeys, which constitute a special case, only two of the sitting animals, the fox (fig. 30) and the cat, have a base, which takes the form of a molded mass underneath the body rather than a fixed anchorage.

The large-scale bird figures, on the other hand, are inconceivable without some support between or behind the legs (see fig. 32). Optically, of course, this supporting element could to some extent be pushed into the background if its color contrasted with that of the legs (see fig. 25), but one must consider what

26

Lion, Kirchner, ca. 1731-32,

H. 50 cm, Dresden

the modelers did, simply by structural means, to ensure that the base contributed to the total impression, not just as a technical necessity, but as part of the artistic design. In some of Kaendler's earliest works, the bird figures are simply stuck on such supports (fig. 21). In others there are hesitant attempts to conceal the link with a few leaves, a device that was later employed repeatedly. Concealment worked particularly well with water birds; a cylindrical support could be disguised as a cluster of vertical reeds, and the bent tips of the reeds distracted attention from the formal function they performed lower down. Kaendler first used this device in the figure of the heron (fig. 17), and he retained it in a few other cases, such as the bittern. Finally the pheasant, one of the last bird figures he made for the Japanese Palace (in March 1735), affords one of the most ingenious solutions (fig. 31). The base, there for purely technical reasons, conveys not only the place, but also hints at the moment and the character of an event.

In the bittern there are also the makings of a narrative characterization that emerges solely from the bird's posture without resorting to additional features. The bittern stands among the reeds; this already defines the bird's habitat. Its erect neck and pointed beak, aimed like an arrow, suggest that it is intently observing something or listening. The feathers are ruffled, making the long, thin neck seem much thicker and contributing to the bird's threatening display. Like the pricked ears of a mammal, the bird's wide-fanning feathers indicate a tense situation. In addition to location, the portrayal captures a moment in time, a moment of extreme concentration. The sculpture does not, of course, reveal what has seized the bittern's attention, but the narrative character of the work emerges

from the form of represention that Kaendler has chosen. Something can be learned about the nature of the bird by carefully observing the figure. This form of characterization is typical of Kaendler's sculptures. It is possible, just by looking at his works – without any background knowledge of porcelain technique, the theory of composition, or iconography – to appreciate the extraordinary genius of the sculptor. The art of outlining a story through the work itself (by selecting a particular moment to represent) and of characterizing a living creature is quite unlike what one finds in Kirchner's animal figures, which are not really convincing unless one is familiar with their literary and cultural connections.

THE MEISSEN ANIMAL FIGURES AS PART OF THE PLAN FOR THE JAPANESE PALACE

Almost every one of Augustus the Strong's palaces could boast its own menagerie, but the one at the Japanese Palace was a special case and had close links to the plan for the building.

Initially, the porcelain sculptures demonstrated to the visitor that the king could afford to have animals made in a material that, in about 1735, was one of the most costly and coveted luxury goods of the age. This perception was enhanced by the artistic virtuosity of Kaendler's sculptures and the sense of being brought face to face with living creatures that had, as it were, been frozen. The figures also were impressive for their monumental format, hitherto unknown in this medium, and embodied the seemingly limitless potential of the royal factory. This perception was supported by their formal artistry, which was seen to have freed itself entirely from Oriental influence, and so made a substantial contribution to the development of European animal

sculpture. To be confronted with the animal as an artistic theme – a theme now patently detached from a tradition that was intent on symbolic effect – must have been as impressive as the novel handling of the material. At a third level, the palace could be interpreted, given the Baroque fondness for symbols and abstractions, as a model residence: the animals were not simply intended to represent a menagerie but, being located within the complex, were probably thought of as a kind of royal household. This notion is supported by the fact that the animals chosen included only those that contemporary scientific zoology described as animals of a higher order. The equation of these animals with real-life courtiers in the throne room is only faintly suggested, but in the Baroque age it was customary for educated people to see artistic representations of animals as allegories for human values or human society, and hence to themselves. And if, in Kaendler's case, this could not be done in the individual work, it was nevertheless possible within the porcelain menagerie as a whole. Admittedly, if all the animal figures had been portrayed in accordance with Kirchner's understanding of animals, a hierarchy corresponding to the one we find in human society would have been more evident. Kirchner's lion is conceived of as a king, and this allows the lion to be equated with a human king. Yet that argument removes the possibility of also seeing the lion simply as an animal. Hence, what was for the contemporary viewer a quite surprising situation – that of seeing, all at once, a costly, virtuoso work of art, an animal, and a possible counterpart of himself in the animal world – would have been seriously impaired. Yet this subtle, multi-layered vision was just what Kaendler's formulations made possible, and it was

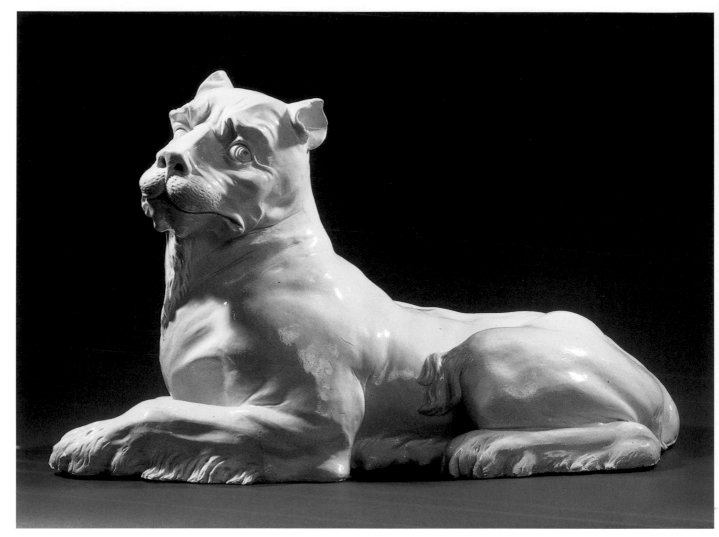

a vision that corresponded to the equally complex palace project. It has already been put forth that the notion of an animal gallery arose at the very time (the summer of 1730) when a change of plan was about to alter the residential character of the building.

THE END OF WORK ON THE JAPANESE PALACE

As has been said, the animal sculptures, especially the large ones, were intended only for the royal collection in the Japanese Palace. In his report of October 1730, Keyssler stated that when the required number of examples had been made, the plaster molds were to be destroyed, lest the figures should forfeit their rarity.[14] Even if this was not done immediately, the historical sources make it quite clear that the larger animals were manufactured solely for the palace and were

to be delivered to no other address. Comparing the holdings it had in 1736 (159 mammals and 319 birds) with the numbers recorded in the inventory of 1770 (110 mammals and 224 birds) one can see that after the project was abandoned a number of animal figures were removed from the palace and found their way elsewhere – to the Tower Room of Dresden Castle, for instance – though a detailed comparison shows that this was true of only small and medium formats.

There were two exceptions in the 1730s. In 1737 Moritz of Saxony, the half-

14 See footnote 2

27

Lioness, Detail of fig. 27

Kirchner, 1732,

H. 49 cm,

Dresden

brother of Augustus III, was given a large but damaged monkey and a large owl, and Count von Altheim, the emperor's stable master, was allowed to acquire two monkeys, which, judging from the price, were of medium size. By 1735 the smaller models, especially birds, were being manufactured for sale and handled by the factory's retail department.

The fact that there are now some large-scale animal sculptures from Meissen in private or public collections is due to the history of the porcelain collection after work on the palace came to an end in about 1740. This resulted partly from insistent complaints from the factory that it could no longer satisfy the growing demand for its products, as the most important experts were engaged in meeting royal commissions. A source from 1739 states that work on orders for the palace, and hence on animal figures, had ceased because the tableware ordered by Count Brühl – which later became famous as the Swan Service – left the modelers and formers no time for any other work, either for royal orders or "current wares" (that is, retail goods).[15] The definitive cessation of work could not be reversed by reminders issued to the factory in the 1740s, for the symbols of royal status had begun to change:

Augustus the Strong's strong belief that his power was mirrored in the splendor of his porcelain no longer held sway.

THE FATE OF THE FIGURES

It was not only deliveries of porcelain to the palace that gradually stopped. Its interior decoration, which had proceeded halfheartedly until 1738-40 – the supply of wall coverings, mirrors, consoles, and the like – was also discontinued. Jonas Hanway, an Englishman who passed through Dresden shortly after 1750 and inspected the palace (which could be arranged by paying a fee to the master of the bedchamber), published an account of his visit in 1753. He was impressed by the amount of porcelain the palace contained, but noted that some of it stood on tables, some on the floor, and some was even packed in chests.[16] Large quantities of furniture and draperies were removed in 1759 to furnish the palace of the crown prince – which shows that the Japanese Palace had by then come to be regarded as a kind of furniture depository for the

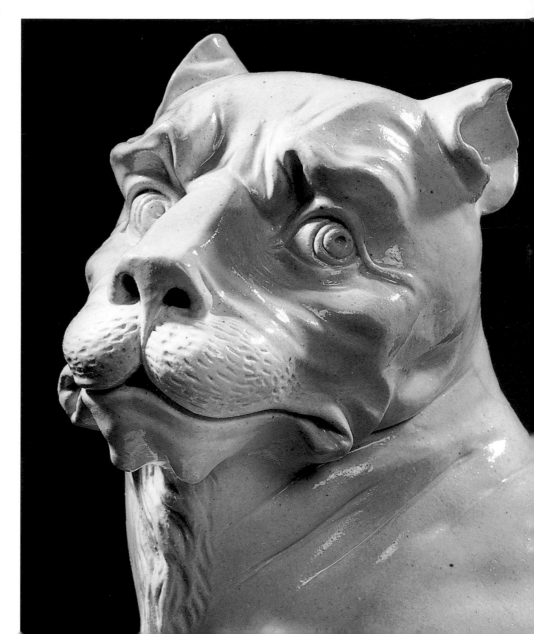

15 BA, 1Ae. 5, fol. 314a

16 See footnote 6

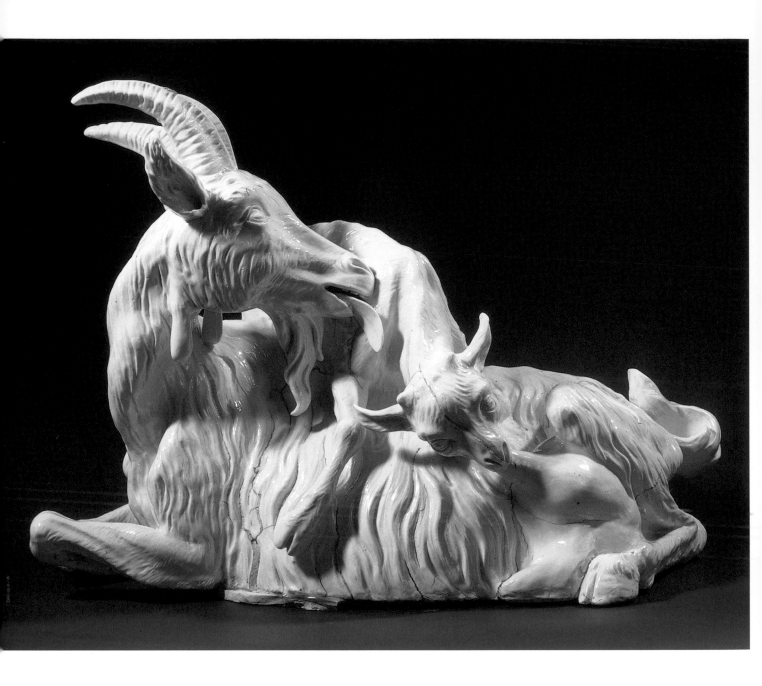

court. At this time – during the Seven Years' War of 1756-63 – the building was used for storing straw, and the porcelain was relegated to the basement. The only pieces spared this fate were the small or medium-size animal sculptures kept in the so-called Tower Room of the old residence and a few other works from the royal collection.

When peace arrived in 1763 the Saxon electors, who had for two generations also been kings of Poland, lost the Polish crown. This political change, which had serious consequences for the ruling house, was paralleled throughout Europe by a change of taste: the Rococo gave way to Classicism and to the enthusiasm for antiquities that went with it.

28

Nanny Goat with Suckling Kid,

Kaendler, 1732,

H. 49 cm,

Dresden

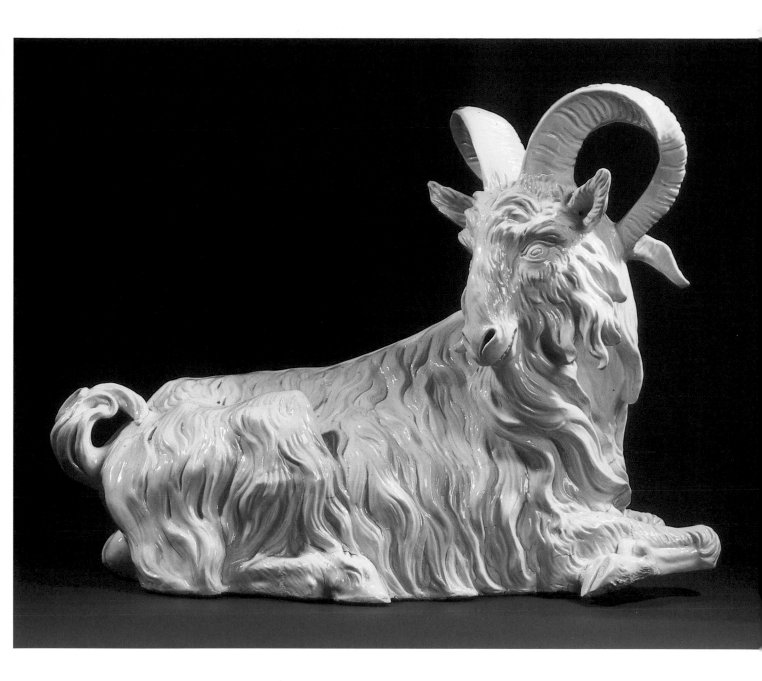

At last, in 1782, under the influence of Camillo Marcolini (privy councillor, commissioner for the art collections, and director of the Meissen Porcelain Factory), the Japanese Palace was for the first time given a real function: as a *Museum usui patens* – almost a museum in the modern sense of the word. It housed the royal collection of antiquities and, from

1786, the coin cabinet and the library. This necessitated some changes in the layout of the rooms. The porcelain collection was organized and made accessible as part of the museum display, though it remained in its unattractive basement. Marcolini pleaded for some of the most notable pieces to be accommodated in the Zwinger, but it was not until 1876 that

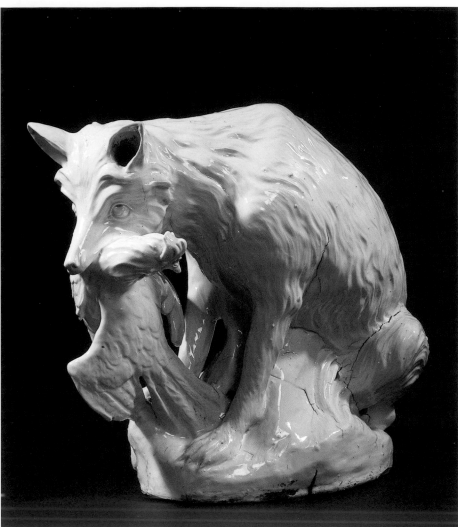

celain Collection, special attention has always been paid to the animal figures. Their monumental format and the artistically convincing portrayal of the animals do not seem to have been tied to a particular age in the same way as other products of the Meissen factory. Yet when duplicates were sold off in order to bring in money and save space, especially in the first half of the nineteenth century, some of the animal sculptures were sold as well. In 1836-37 six large animal figures were exchanged for French porcelain from the Musée National de Céramique at Sèvres. This testifies to a wish to turn the historic collection of the eighteenth-century Saxon electors into a comprehensive museum of ceramics – an idea that persisted until the beginning of the twentieth century and was pursued by other museums too, including the one at Sèvres. In 1919 and 1920, again with the aim of fund raising, two highly regarded sales took place at Rudolph Lepke's auction house in Berlin. Among the items offered were works of art from the Dresden collections, including many pieces of Oriental and Meissen porcelain. There were 277 lots of Meissen porcelain at the two sales, and of these, 26 were fairly large animal sculptures that had once been commissioned for the Japanese Palace. Because the auctions were so successful, and the museum, under the directorship of Ernst Zimmermann, wished to avoid financial hardship by engaging in direct exchanges, it had by 1933 disposed of nine more

the porcelain, along with the paintings collection, was moved from the palace to the former stable building, known as the Johanneum.

These three changes of location reflect the importance attached to the porcelain at different times. It was first acquired as an element in the furnishing of the palace and reflected the status of the ruler. In the last third of the century, it became part of a museum display, though at first it was clearly less important than the other collections. In 1787, however, Marcolini, as head of the factory, reported

that the porcelain pieces were no longer to be considered part of the furnishings, as they once had been, but as works of art. It was in this spirit that Gustav Klemm was appointed curator of the collection in 1833 and that the first printed guide appeared in 1834. In 1876 the porcelain was moved to the large, bright rooms of the Johanneum, the building that housed the royal paintings collection, demonstrating the interest that art experts were beginning to show in porcelain (fig. 34).

In all of these moves, and in all the commentaries about the Dresden Por-

large-scale animal figures, of which it had duplicates. In almost all cases they were sold through the Berlin auction houses of Hermann Ball and Arthur Wittekind. In return the museum received small figures by Kaendler from the second quarter of the eighteenth century as well as cash. On October 24, 1931, for instance, the large bittern that is now in the Rijksmuseum passed to Arthur Wittekind, together with a rose-ringed parakeet, in return for two thousand thalers and Kaendler's group *Der Herzdosenkauf* from the Rothschild collection. On November 30, 1932, through the agency of Hermann Ball, Zimmermann exchanged the large blue parrot, now in the Rijksmuseum, and two early small-scale bird figures for another crinoline group by Kaendler. Under the compensation settlement for the German princes after the First World War, the

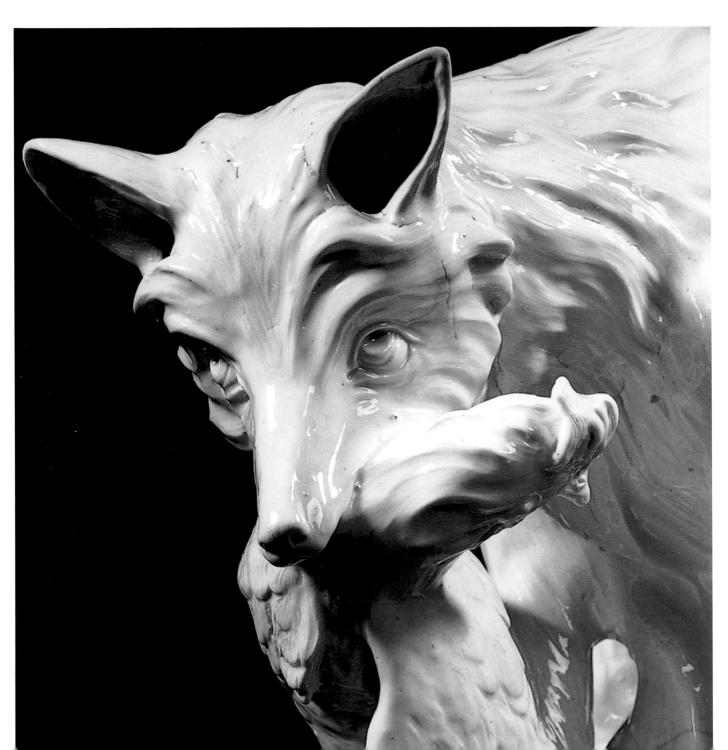

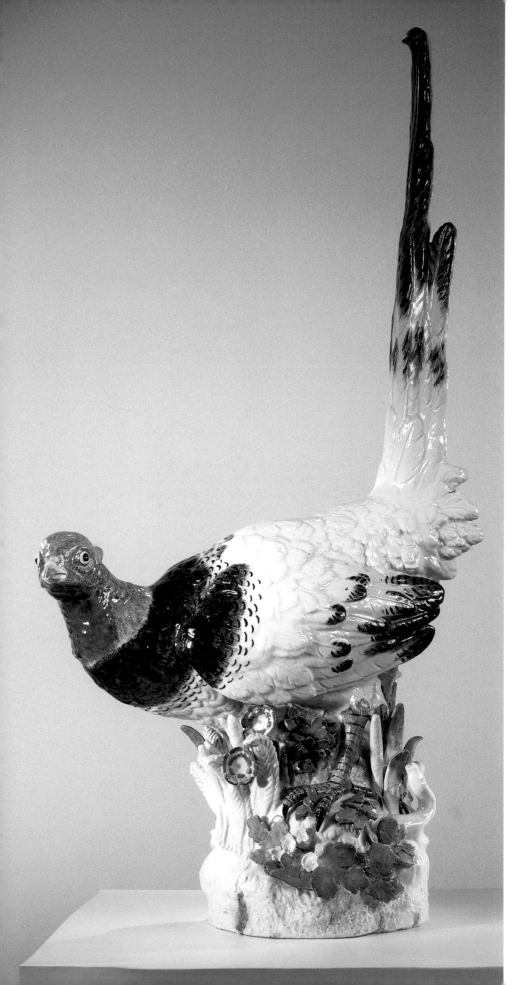

house of Wettin received six animal figures. The Second World War took its toll too, so that today, of the 53 different models of medium-size or large animal sculptures (those more than forty centimeters tall) the Dresden Porcelain Collection contains 107 sculptures – a bare third of the 334 that were once in the royal collection, according to the inventory of 1770.

FORGERIES

Complete forgeries of large-scale Meissen animal sculptures – models that have been copied exactly outside the factory and purport, either with or without a false mark, to be originals from the Japanese Palace – are comparatively rare (unlike those of small-scale figures). Apart from the intuition that comes with experience of the material, there is a simple, rational way to determine the authenticity of a piece: not only must the size agree with an authenticated example to within a few centimeters, the details of a bird's plumage or an animal's fur must agree as well. The former has insufficient scope to rework whole areas of feathers or hair. A detailed comparison of the feathers or skin ensures a fair degree of certainty, for the cost of producing such a forgery would be too great to be worth the forger's while – apart from the fact that he would need to have direct access to an original. This is borne out by the new versions of animal figures made at the Meissen factory between 1915 and 1936, for which the

31

Pheasant,

Kaendler, 1735,

H. 75.5 cm,

Amsterdam

32

Golden Pheasant,

Kaendler, 1731,

H. 75 cm,

Amsterdam

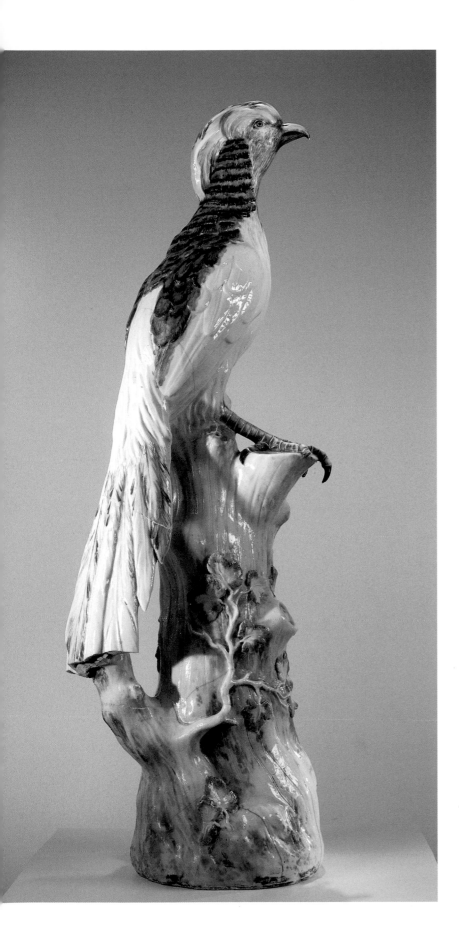

original molds were lost and had to be laboriously reconstructed. After 1736, or in the nineteenth century, only two models of large animal sculptures were reproduced and exported (to England), the wood demon (baboon) and the Bolognese dog by Kirchner.

For the reproduction of models in the twentieth century, originals in museums or private collections were copied as accurately as possible, as the factory records testify. Comparing the animal sculptures of the 1730s with their modern descendants, made about two hundred years later, one finds numerous differences in the detailed structure. Even the Meissen masters of the early twentieth century could not simply use a mold made from an old example, for after the last firing the size of the copy would differ by one-sixth from that of the original.

However, about the turn of the century, copies of a few fairly large models were made in other porcelain factories as well; these bear no mark, or the original mark is imitated, and they would be described as forgeries in the modern understanding of the term. Shortly before 1900, for instance, the Potschappel works at Freithal near Dresden offered for sale not only copies of many small Meissen figures, but also of the large wood demon and the Paduan cockerel. They differ distinctly from the originals in their detail, as do the medium-size models copied by the French firm of Samson.

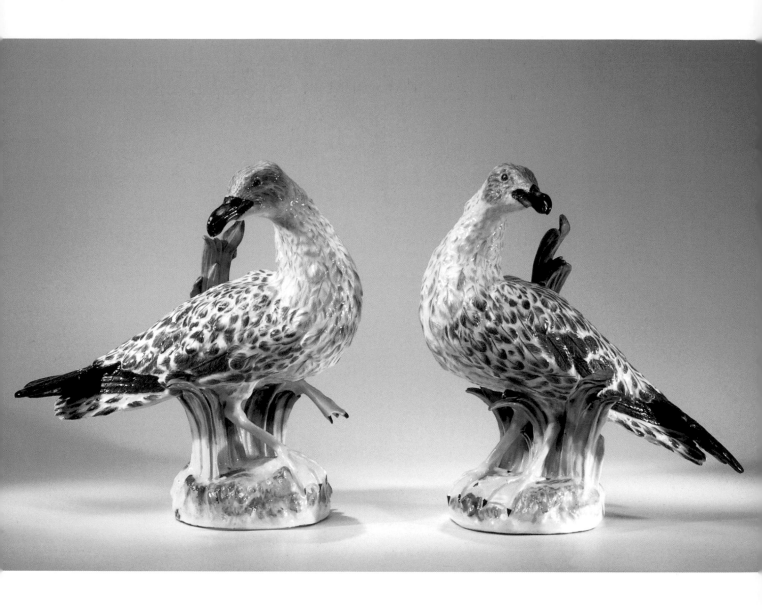

33

Pair of Sea Gulls, Kaendler, ca. 1750,

H. 27.8 cm, Amsterdam

MEISSEN PORCELAIN ANIMALS IN THE RIJKSMUSEUM – AN ASSESSMENT

The large-scale animal sculptures that left Dresden over the past two hundred years are now dispersed throughout the world in public and private collections. Only rarely are several found together. This is due in part to the high prices these incunables of European porcelain sculpture have commanded from the beginning. Even the production costs charged to Augustus the Strong were enormously high when one considers, for instance, that the sum of 309 thalers charged for

a cassowary in 1734 was almost exactly equal to three-quarters of the annual salary paid to Johann Kaendler, the master modeler.

Many of the animal sculptures outside Dresden are distinguished by their relatively good quality in regard to their mass and condition. In all the sales of duplicates that have been mentioned, the vendor was careful to dispose of well-preserved pieces that would sell for a higher price. The preface to the auction catalogue of 1919 confirms this assumption, stating that the defects of the pieces

34

Gallery with Meissen
porcelain in the
Johanneum,
Dresden, ca. 1900

35

Gallery with Meissen
porcelain in the
Zwinger,
Dresden, ca. 1960

on offer are only slight and that the firing cracks are comparable to those on the remaining pieces. English visitors to Dresden in the nineteenth and early twentieth centuries were so delighted by the animals in the palace that they tried hard to acquire some of them. Longleat today still has ten large animal sculptures, and Raby Castle five. The collection of Lord Hastings was dispersed and sold at Sotheby's in 1950. It was only in the twentieth century that the Pflueger collection in New York and Ernst Schneider's collection at Lustheim, near Munich, were formed; the former includes eight palace animals and the latter, four large-scale figures.

Beside the porcelain collections in Dresden, the Musée National de Céramique at Sèvres (with six large-scale animal sculptures), and the Museo Civico in Turin (with three palace animals), the Rijksmuseum in Amsterdam is unique among public collections for its quantity and quality of animals. Of the three monkeys and eight birds that were made for the Japanese Palace, all but the golden pheasant (fig. 32) came from the Mannheimer collection. Most were acquired as early as 1952, but the later acquisitions also come from that private collection, which was assembled between 1925 and 1936 and acquired large-scale animal sculptures partly as a result of the sale of duplicates between 1919 and 1933. The golden pheasant, the most recent figure acquired by the Rijksmuseum, came directly from the Dresden Porcelain Collection in 1963.

The animal figures that originally stood in the Japanese Palace are supplemented by two sea gulls (fig. 33) and two small bitterns (fig. 36), the models of which were made by Kaendler after the palace project had been abandoned. The latter pair demonstrates that the factory produced small replicas of the large-scale royal figures and that these replicas were sold freely.

A notable item in the Rijksmuseum's collection is the parrot (fig. 10), the only known example of this model. Kaendler modeled the small bird between October and December 1731, most probably after a graphic archetype.

45

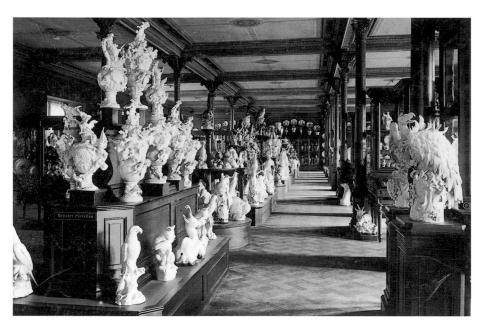

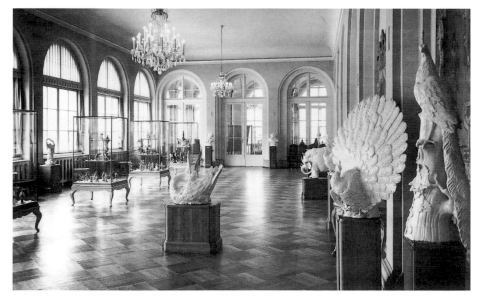

The mark *AR* on the unglazed base links it with most of the other palace birds of this format. Moreover it fully satisfies Augustus the Strong's requirements: first, it is a life-size figure and, second, it is painted in nearly natural colors. The decoration testifies to another special feature of the Amsterdam collection: all the animal figures, of whatever format, are painted with fired colors. The historical sources and lists note that the smaller figures were usually decorated in this manner, but that some very large models in the Rijksmuseum, such as the macaw and the golden pheasant, were enameled. Once the authenticity of the sculptures has been confirmed by comparing them, in terms of detail, mass, and size, with authenticated models in Dresden, a question arises: When were the individual Amsterdam figures painted? As no investigations have so far been conducted using today's rapidly advancing scientific methods, comparisons with figures in other collections must suffice.

The core issue is that some decorations have neither the glaze and fineness of application nor the color harmony that one would expect from the apex of Meissen porcelain painting. This phenomenon applies to the early, brightly enameled palace animals in general, not just to those in the Rijksmuseum. Two considerations suggest that the Amsterdam animals are probably not only all old models, but were also painted at this early period.

Considering the extent of the artists' experience with figure decoration in the early 1730s, one realizes that this is an area in which hardly any work had been done. A comparison of the quality of the painting of the Temple of Venus in the Rijksmuseum, which dates from before 1730, with that of the large macaw (fig. 13) reveals parallels. The application of the

paint, which is technically comparable to watercolor painting, is hardly shaded, or the shading is patchy and hard. Small strokes in other, dark colors are used in an attempt to replace the effect of the surface relief, which has lost much of its effectiveness in conveying depth through the use of color (note the tail feathers of the macaw). Finally, powerful and highly contrasting color combinations ensure a vivid overall effect; this amounts to an attempt to replace the play of light and shade in the sculpted model with brighter or darker color tones. This conception of decoration, which essentially derives from painting, is not much in keeping with the image we have today of Meissen figure painting.

The famous, finely painted, small-scale figure models that determine this image (the shepherds, commedia dell'arte figures, crinoline groups, etc.) were created by Kaendler after 1736, when large-scale animal sculptures were no longer being made. Because of their format, they were meant to be viewed at close quarters. In the case of the animal sculptures, however, this was never intended, and the artists were aware of this when they made them. The intention was to paint the animal figures in such a way that they would be most effective when viewed from a distance: according to Keyssler's account the gallery was some eleven meters high. This might be considered an explanation for the general flatness and the virtual absence of the more subtle kind of shading and internal drawing. To this extent both the use of color and the choice of tones, sometimes highly contrasting, functioned in much the same way as the brightly colored figures on a Baroque altar.

Weighing all these considerations, it becomes clear that an appreciation of the color decoration of the animal figures is

not primarily a problem of the time at which they were made, but one of our modern expectations and habits of perception. It is fairly difficult, in light of the Amsterdam figure of the golden pheasant (fig. 32), to free ourselves both from past aesthetic perceptions (about which little has come down to us anyway) and from our own taste, which is dictated by our own age, in order to be able to make sense of the patchy painting and the coloring of the bases with as much objectivity and reflection as possible. The curious color that dominates the tree stump forming the base of the figure appears in minute traces on other palace animals, which were nevertheless colored with oil paint.

Count Sulkowski is said to have complained in 1734 about the attitude and "unnatural" painting of the palace animals. Because he was responsible for executing the plans for the palace, he expressed this view to Kaendler, as Höroldt stated in a report. But the count was referring to the figures painted with oils, and the artists in the factory were still looking for a satisfactory method for employing colors. For instance, a comparison of the parts of the macaw (fig. 13) that are painted blue and the golden pheasant (fig. 32), both decorated in 1731-32, with those of the pheasant (fig. 31), decorated in June/July 1735, reveals the purely technical development that took place in just a few years.

To this extent the porcelain animals in the Rijksmuseum afford not only a representative survey of the technical and artistic development of the models for the Japanese Palace, but also a unique opportunity to study the evolution of color decoration. In this sense the collection is not just an assemblage of a few historical porcelain sculptures, but a splendid little menagerie in its own right.

46

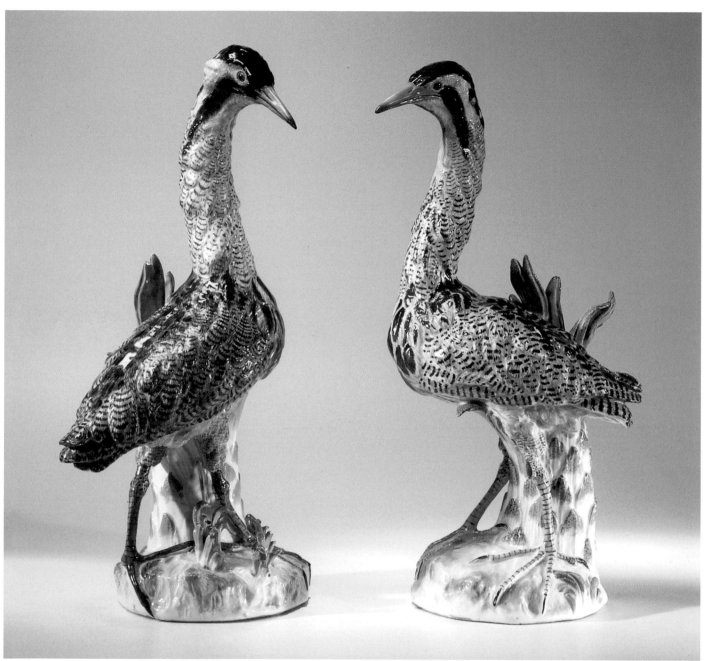

36

Pair of Bitterns, Kaendler, ca. 1750,

H. 37 cm, Amsterdam

Select Bibliography

Albiker, Carl, *Die Meissener Porzellantiere im 18. Jahrhundert*, Berlin, 1935.

Berling, Karl, *Das Meissener Porzellan und seine Geschichte*, Leipzig, 1900.

Cassidy-Geiger, Maureen, "Meissen Porcelain Ordered for the Japanese Palace," *Keramos* 153 (1996), pp. 119-30.

Fichtner, Fritz, "Von der kurfürstlichen Kunstkammer zur Porzellangalerie im Dresdener Zwinger," *Berichte der Deutschen Keramischen Gesellschaft* 20 (1939), pp. 293-309; 21 (1940), pp. 237-64; 22 (1941), pp. 330-70, Berlin, 1939-41.

Franz, Heinrich Gerhard, *Zacharias Longuelune und die Baukunst des 18. Jahrhunderts in Dresden*, Berlin, 1953.

Gröger, Helmuth, *Johann Joachim Kaendler, der Meister des Meissener Porzellans*, Dresden, 1956.

Hanway, Jonas, *An Historical Account of the British Trade over the Caspian Sea, with a Journal of Travels from London through Russia into Persia, and back through Russia, Germany, and Holland*, London, 1753 (2 vols).

Heres, Gerald, *Dresdener Kunstsammlungen im 18. Jahrhundert*, Leipzig, 1991.

Horschik, Josef, "Die vergessene Bemalung der grossen Meissener Porzellantiere," *Keramos* 78 (1977), pp. 13-18.

Keyssler, Johann Georg, *Neueste Reisen durch Deutschland, Böhmen, Ungarn, die Schweiz, und Lothringen*, 2nd edn., Hanover, 1751 (1st edn., Hanover, 1740).

Keyssler, John George, *Travels through Germany, Bohemia, Hungary, Switzerland, Italy, and Lorrain: giving a true and just description of the state of those countries . . .* (translated from the 2nd edn. of the German), London, 1756-57.

Klemm, Gustav, *Die Königlich Sächsische Porzellansammlung. Ein Überblick ihrer vorzüglichsten Schätze, nebst Nachweisungen über die Geschichte der Gefässbildnerei in Thon und Porzellan*, Dresden, 1834.

de Lairesse, Gérard, *Het groot schilderboek*, Amsterdam, 1707 (2 vols).

Rückert, Rainer, "Christian Reinow und die grossformatigen Tierfiguren aus Meissener Porzellan," *Staatliche Kunstsammlungen Dresden, Jahrbuch 1989-90*, pp. 47-52, Dresden, 1992-93.

Schlechte, Monika, "Der barocke Tiergarten Moritzburg," *Staatliche Kunstsammlungen Dresden, Jahrbuch 16* (1984), pp. 23-42, Dresden, 1985.

Sponsel, Jean Louis, *Kabinettstücke der Meissner Porzellan-Manufaktur von Johann Joachim Kaendler*, Leipzig, 1900.

Walcha, Otto, *Meissener Porzellan*, Dresden, 1973 (translated by Edmund Launert under the title *Meissen Porcelain*, New York, 1981).

Zimmermann, Ernst, *Meissener Porzellan*, Leipzig, 1926.

At the Rijksmuseum and Uitgeverij Waanders:
Jan Daniël van Dam, *Editor*
Berry Slok, *Designer*

At the J. Paul Getty Museum:
Christopher Hudson, *Publisher*
Mark Greenberg, *Managing Editor*
Catherine Comeau, *Editor*

Photographs:
Department of Photography Rijksmuseum –
Peter Mookhoek – with the exception of
illustrations 1-2 (Fotothek der Sächsischen
Landesbibliothek), 3-5 (Sächsisches Hauptstaatsarchiv), 34 (Max Fischer, Dresden),
and 35 (Ernst Schäfer, Weimar)

Copyright © 2000 Rijksmuseum, Amsterdam,
and Uitgeverij Waanders b.v., Zwolle

Published in English in 2001 by the J. Paul Getty
Museum, 1200 Getty Center Drive, Los Angeles,
California 90049-1687

By Samuel Wittwer

Translation:
David McLintock, London (German-English)

ISBN: 0-89236-644-3

Library of Congress Control Number: 2001087662

Printed by Waanders Printers, Zwolle,
The Netherlands